£5

Sold to the Man with the Tin Leg

Also by Philip Serrell

AN AUCTIONEER'S LOT

PHILIP SERRELL

Sold to the Man with the Tin Leg

HODDER &
STOUGHTON

Copyright © 2006 by Philip Serrell

First published in Great Britain in 2006 by Hodder & Stoughton
A division of Hodder Headline

A Hodder & Stoughton book

2

A CIP catalogue record for this title is available from the British Library

ISBN 0 340 89502 0

Typeset in Sabon by Hewer Text UK Ltd, Edinburgh
Printed and bound by Clays Ltd, St Ives plc

Hodder Headline's policy is to use papers that are natural, renewable
and recyclable products and made from wood grown in sustainable
forests. The logging and manufacturing processes are expected to
conform to the environmental regulations of the country of origin.

Hodder & Stoughton Ltd
A division of Hodder Headline
338 Euston Road
London NW1 3BH

To Clem

I have thoroughly enjoyed my thirty years as an auctioneer in rural Worcestershire. I hope you enjoy these stories based upon the characters, successes and calamities that I was lucky enough to experience in the early years of my career.

Contents

Chapter One

Sold to the Man with the Tin Leg

It was the summer of 1977 and I was in the saleroom with my boss, Mr Rayer. He was a man of about sixty-five and was dressed in his trademark tweed jacket, which bore the burn marks and battle scars of many a pipe-lighting episode. His full name was Major Ernest Edward Foley Rayer, MBE, TD, FRICS, CAAV, the letters representing his military and professional qualifications and achievements. But he was such a self-effacing character that he had long since dispensed with his military title. Me, well, I was a young, wet-behind-the-ears trainee, who had had the good fortune to find a job with Bentley, Hobbs and Mytton, a long-established firm of auctioneers, valuers, surveyors and estate agents. Mr Rayer was an employer in a million: cantankerous, stubborn, utterly professional and keen to impart knowledge to his new pupil who, eighteen months beforehand, had been a PE student.

Mr Rayer had another distinguishing feature: he had a

tin leg. Shortly before the end of the Second World War his leg had been shot off in battle and he had been lucky to survive. This minor disablement, as he saw it, did not stop him living his life to the full. 'The Galloping Major' was one of his nicknames – a result of his passion for riding out with the hounds. His complete inability to keep an appointment on time had led to another: 'Ten o'Clock Ted'.

'Philip, it's time for you to take part of a sale.'

I could hardly believe my ears. He was going to let me – the twenty-two-year-old office boy – have a go.

We auctioned an interesting and eclectic collection of items. There were usually about five hundred lots, with eighteenth-century tables scattered among three-piece suites and washing-machines. The saleroom in Malvern was a marvellous building: it was a former church hall, built of local stone with a deeply pitched tile roof. Inside, a vaulted wooden ceiling stretched the length of the room with a stage at the far end upon which stood the auctioneer's rostrum. Everyone looked up to the auctioneer, literally and metaphorically, and at the next sale it would be my stage.

It was my job to 'lot up' sales. Put simply, this meant attaching lot numbers to the items but it involved describing them too, about eight to an A4-sized sheet. On this occasion, as I lotted up, I couldn't help but wonder which of the items I would be selling. If I was lucky it might be some of the furniture, which was normally

where the high-value lots were to be found. No – when I thought about it, I knew Mr Rayer wouldn't let me loose for the first time on the better pieces. He had a duty to do the best by his client, and to let the lad sell the important lots would certainly not fulfil that obligation. It would probably be among the 'smalls' that I would cut my teeth, where the values normally ranged from tens of pounds to a few hundred. As I wandered around the saleroom I practised under my breath: 'Ten pounds bid, fifteen, twenty now, and five, thirty, thirty-five, any more?' Down comes the hammer and 'Sold to the lady in the blue dress!' I thought the last bit was clever. I knew from watching the others that a bit of banter was vital to being a good auctioneer: it forged a relationship between him and the bidders.

As I daydreamed round the room I got more carried away: 'One hundred, one twenty, one fifty, one eighty, two hundred, two twenty . . . All done, then? Yours, with the pink glasses!' I was really pleased with my patter – distinguishing a characteristic of the buyer was a masterstroke, I thought. Perhaps I'd even get close to the magical thousand-pound figure, which would mean I had sold a really important piece. Quickly I brought myself back to reality and finished lotting up with the lesser items and effects, which would be put outside the saleroom on the morning of the auction.

For the rest of the week I practised my auctioneering skills. In the car and in the bath, I went through all the

bidding increments I could imagine. I was keen to develop my own style, and I knew I had to concentrate on the bidders to make what I thought was a witty remark that identified them. At long last the sale day arrived. I thought it was important that I looked the part and not like a new boy: I was going to be a country auctioneer so I should dress like one. Corduroys and tweeds with brown Oxford shoes were the answer. I had the trousers but not the right jacket or footwear. It was time to raid my father's wardrobe. He wasn't a fashion icon and bought a new outfit when the old one had worn out so most of his clothes was at least twenty years old. Eventually I found two items that seemed to fit the bill: a smart Harris tweed jacket and old polished brogues, which I secreted away until the important day arrived.

I got up early on sale day and carefully donned my new attire. On reflection this was probably not a great idea: my father took a jacket size larger than I did and his shoes were smaller. The jacket I could put up with, but my feet felt as if someone had welded razor blades to the toecaps.

My confidence was knocked a bit when I arrived at the saleroom. 'You been to the Oxfam shop?' asked one of the dealers.

'If you're going to wear a dead man's clothes, try to find a corpse the same size!' said another.

I walked on, pretending I hadn't heard, and met Mr Rayer in the office.

'Philip, it's important that you learn to walk before you run so I'll only give you a few lots today. This is a bit of a taster for you and you won't be selling at every sale.'

Not only had I entertained visions of selling at every sale but I'd thought I might get to sell at least a hundred lots. Mr Rayer had swiftly brought my daydreams back to reality. It was now apparent that I would not be selling the furniture. Instead, I thought, I would have to be content with the silver, porcelain and other smalls. I felt a little deflated. As if that wasn't enough, he followed up with 'Having trouble with corns? You seem to be hopping from one foot to the other.'

My attempt to look like a country auctioneer had failed – clothing from a corpse with corns was not overly complimentary. Despite my garb, though, I remained resolute, and, with a brave face, took to the stage alongside my boss.

At the start of the auction my job was to act as clerk to Mr Rayer: I would stand beside him and record the buyer and the price paid for each lot on the sale sheets. The furniture seemed to take an age but I watched all of the bidders eagerly, looking for the one characteristic I could pick out when it was my turn to sell. We moved on to the smalls: there were about two hundred lots left in the saleroom before we would move outside. I reckoned Mr Rayer would leave me with about the last fifty smalls. Mentally I was going through my paces, 'Thirty-five, forty, forty-five, fifty – yours, in the trilby hat, sir.' As we

got to the last hundred or so of the inside lots I started to get a little nervous; my anxiety was only matched by the pain in my feet, which felt as though the toenails were being ripped off. When I glanced at my – or, rather, my father's – shoes I half expected to see blood running out of them. I had been on my feet now for nearly four and a half hours and was in agony. I would never again be a fashion victim, good or bad.

Mr Rayer carried on. I thought perhaps he had forgotten that I was going to sell so I coughed to remind him I was still there.

'You'll never make an auctioneer coughing like that, Philip. And, for goodness' sake, stand still!' Well, at least he knew I hadn't gone home.

He carried on in his own style and finished the smalls. There were now only the twenty outside lots left and my dream of selling something for a hundred pounds was rapidly evaporating. Still Mr Rayer carried on, until three lots remained: a tennis net with just its top, bottom and sides – leaving one huge hole in the middle – ten rusting cast-iron hospital radiators, and a butcher's block with woodworm and no legs.

'I'll now hand you over to Philip Serrell, who will offer the last lots in the sale.'

Not quite what I'd anticipated and my mind was a little distracted by my feet, which now felt like raw steaks being put through a mincer. Mr Rayer handed me the gavel: I had no way out. It was not how I had

envisaged starting, but now at least I could claim to be an auctioneer.

'The tennis net, where will you start me?'

Silence.

'Come on. Bid me!'

Silence.

'Pass it by, Philip. Move on to the next.'

My confidence was plummeting.

'There you are, then, the next lot, the radiators. Ten pounds, someone?'

Silence.

'Five, then?'

Silence.

Again the stage whisper roared in my ear: 'Pass it by, Philip. Move on – you've got to keep the momentum going.'

That was fine, but so far I hadn't gathered any momentum. I had practised every eventuality of the public bidding. It hadn't occurred to me that there would be no bidding. Sweat was now dripping off my forehead from a mixture of nerves and pain. 'The butcher's block, then. Five pounds somewhere?' I was getting used to the silence – it was rather like giving a monologue.

'Two pounds, then?' Still silence. I was destined to be the first auctioneer who had sold nothing in his first attempt with a gavel. Undeterred, I carried on: 'A pound, then? *Please?*' Panic was setting in.

At last, in an act of sympathy, my boss put up his hand

and shouted, almost as if he was trying deliberately to embarrass the small crowd still standing around me, 'I'll give you a pound, Philip.'

With great relief I brought the gavel down, thinking, Sold, to the man with the tin leg!

Chapter Two

◡

A Large Brown Patch

The polished brass nameplate outside the offices of Bentley, Hobbs and Mytton said, 'Estate Agents, Auctioneers, Valuers and Surveyors'. Mr Rayer was a seasoned practitioner in all of these disciplines and was adamant that I should have a broad experience in each before I decided which was for me. Now it was time for surveying. Even though livestock markets made me a bit jumpy – the lots on offer either kicked you or, worse, decided that your clothes needed an instant deposit of manure – I thoroughly enjoyed the auction side of the business. Auctions are the acid test of the valuations that have been provided pre-sale: if Mr Rayer valued an item at a hundred pounds, then offered it for sale, his reputation for accuracy was at stake. The second part of the business, making valuations, was an interesting intellectual exercise: it was an expression of opinion, backed with some expertise and experience, but was never proved right or wrong. As yet I was

unaware of the third element, surveys, but that was about to change.

'Philip, pop out to doings at Campden and measure the hedge.'

After nine months I was less flustered by the dreaded 'doings' – by now a familiar term, frequently used by my boss when referring not only to people but objects as well. 'Doings' could always be worked out from any paperwork Mr Rayer might have; the detective work involved in finding it made the job that bit more of a challenge. Mind you, for Mr Rayer, this instruction was quite clear. It might have been worse – potentially three times worse: 'Pop out to doings at doings and sort the doings out.'

My boss had been instructed to carry out a survey of a cottage in the village of Chipping Campden, about twenty-five miles east of Worcester on the edge of the Cotswold escarpment. Surveys of this nature were required by the prospective purchaser of a house for sale before he or she signed a contract. On this occasion I was to go out and measure the property's hedge. Somewhat foolishly I assumed that Mr Rayer had done the rest and needed this measurement to complete the plan that would accompany his report. It shouldn't prove too problematical, I thought. It was nine thirty in the morning and a trip out on the open road seemed a pretty good way to start the day. I should have known by now that it was always dangerous to make assumptions with Mr Rayer.

A Large Brown Patch

I had recently bought a red Mini, registration number OOB 315G, and called it, not too surprisingly, 'Ooby'. It was a good little car and I could see myself taking an ice-bound pass in the RAC rally, like Paddy Hopkirk did in the 1960s. The trip out to Chipping Campden wasn't a chore, but it wasn't much like a rally either. However, there was Fish Hill on the outskirts of Broadway. There are steep hills and steep hills but Fish Hill was up there with the best. It had those run-off areas with gravel and signs that announced, 'Emergency Road in the Event of Brake Failure', which I had found awfully exciting as a child – I still do, actually. It also had two or three near-hairpin bends, which, with a little imagination, might be taken for those on an Alpine pass.

It was a joy to drive through Broadway, regarded by many as the quaintest of all Cotswold villages, and certainly a must on every American tourist's trip through the middle of England. It is rightly hailed as everything the foreign traveller would want to see in a Cotswold village: honey-coloured mellow stone walls, with either a picturesque thatch or ash-hued slates, some the size of paving slabs. It is a thriving commercial centre, too, with galleries, antiques shops and tea-rooms lining the main street. To me, a trip to Broadway always necessitated a stop and a quick wander round. Gerry O'Brien's gallery was a joy, and he was always happy to share his knowledge and explain the finer points of his latest acquisition. The antiques shops were full of the stock-in-trade of the

Cotswold dealer: country and oak furniture that would appeal to the owners of local properties as well as tourists. They were run by characters similar to Gerry, who were equally keen to show this young man their varied stock. That day as I pulled up outside Gerry's gallery I was feeling so lucky to be in my new career that I had almost forgotten the reason for my trip.

Gerry showed me his latest purchase and I amused him by playing 'Guess the Price'. I was usually out by more digits than there are in a telephone number, but he was ever gracious as he explained why it was worth so much more – or, occasionally, less. An explanation from an expert always opens an amateur's eyes and makes obvious that which was hidden before. I could have spent hours talking to Gerry, who had a wealth of stories to tell. Still, Chipping Campden called and it was time to move on.

I jumped back into the car and set off up Fish Hill. It was like trying to drive up a really steep helter-skelter. I floored Ooby's accelerator but had to ease off half-way up as it had started to rain – I shouldn't have been surprised because it had done little else in the past three weeks. *The Italian Job* filled my mind as spray splashed on to the greasy windscreen, just as it does in the film when the cars go through the water after the theft of the gold. I struggled to see through it, but the wipers just made it worse, and the washers were long since defunct. My father, who, in farming terms, was 'careful' in

matters of finance, had decided I shouldn't get them fixed: his solution was an old Fairy Liquid bottle filled with water, which I aimed through the open window on to the windscreen as the wipers went back and forth. His theory was that the soap left in the empty bottle added to the effectiveness of his device. He couldn't understand why it didn't catch on, but I could. I had bought a pair of string-backed driving gloves, which I thought looked the absolute business; a Fairy Liquid bottle did not support the image I was trying to create. Michael Caine wouldn't wipe his windscreen with the aid of a plastic Fairy bottle.

The rain became heavier, making the bottle of soap suds redundant as the downpour cleaned the windscreen. Unfortunately it also created a waterfall, which cascaded beneath the windscreen into the car, over the dashboard and flooded the footwell in a steady torrent. The water was soon up to the welts of my shoes and rose steadily until the bottom of my trouser legs looked like I had been paddling.

After a while I pulled up outside the property that Mr Rayer had previously surveyed unaccompanied by me. It fronted on to the road into the village and was screened by a particularly prickly hawthorn hedge. The nameplate announced, appropriately enough, that I was standing outside Hawthorn Cottage. The rain was still falling, very heavily indeed now, and I was getting soaked. There appeared to be no activity in the hundred-and-fifty-year-old cottage so I got on with the measuring task, as Mr Rayer had instructed.

The hedge was spiteful. It was about three and a half feet thick and didn't look like it had been cut for about two years. Mr Rayer had given me a linen tape that was a chain long. As a cricket fan, this is the only measurement I can ever remember from the world of rods, poles and perches: a chain is twenty-two yards, or the length of a cricket pitch. The hedge, however, seemed about half as long again. Luckily the tape had a little metal spike and a tag that could be fixed or looped on to an appropriate point as an anchor when there was only one man to hold it. Suddenly it dawned on me what vast progress I had made in the business: when I had started I was Mr Rayer's tape-holder – as the lad in the office was known – and now I was holding *my own tape*. This was responsibility, not to be taken lightly. I decided to measure the hedge three times and take an average. As soon as I began I dropped one end of the tape in the middle of the thickest part and had to fight my way through the thorns and prickles to retrieve it. I was now soaked to the skin and almost speared to death.

'*What the hell do you think you're doing?*' yelled Mr Hawthorn Cottage.

My cries must have aroused those in the house.

'I'm stuck!'

'*He's a Peeping Tom!*' shrilled Mrs Hawthorn Cottage.

Imagination running overtime, I had visions of being arrested. I regained my composure, explained my presence in their hedge and got back to the job I had been

sent out to do. The linen tape seemed to stretch a bit, but eventually I decided it was eighty-seven feet six inches long. Job done. It was time to report back to the office. Ooby ate the miles on the way back to the office; luckily it was quite frugal in the petrol-consumption department and the gauge hardly seemed to move. Given my perilous financial state this was good: I didn't have any money to fill her up.

I arrived back at Mr Rayer's office and proudly announced my result: 'Eighty-seven feet six, Guv'nor.'

I knew from the look on his face that there was a problem: out came the pipe and, after a lot of puffing and about three-quarters of a box of matches, he uttered through the smog, 'I've got it to eighty-eight feet six, Philip.'

Not an insurmountable problem, I thought. Simply add them together and divide by two: eighty-eight feet. This mathematical formula had been my solution to most of the problems I had encountered recently in my enjoyable new career. Unfortunately, I feared, there would be no such easy shortcuts for Mr Rayer. And I was right.

'You'll have to pop out and re-measure it, Philip.'

I could, quite cheerfully, have strangled him. 'Mr Rayer, the hedge was really thick and over that length it could be a couple of feet either way,' I protested.

'To make matters worse, Philip, I've got the Ordnance Survey plan out here and, scaling it off, my reading could be five feet either way.'

I looked at Mr Rayer. His eyes were very bad and his glasses so thick he could have started a bush fire with them. His scale rule looked like it had been chewed by his Labrador, and the plan as if it had recently held cod and chips. The *pièce de résistance*, however, was the pencil he had used to measure the hedge on to a plain piece of paper. It was an inch and a half long with a tip that seemed an inch wider. No wonder we had so many different readings; when you took into account the scale of the plan, the tip of Mr Rayer's pencil represented about ten feet.

I knew better than to argue, however, and set off again for Chipping Campden. Now, anyone with half a brain would have either popped into one of Worcester's cafés for an hour and come back with the right answer or, at worst, driven to Gerry O'Brien's in Broadway for another chat and a cup of tea. Like a lemon, I did neither. I set off for Hawthorn Cottage, thanking my stars that I hadn't had to serve in the army under Major Ernest Edward Foley Rayer.

This time I thought that discretion should be the better part of valour and knocked loudly on the door – I didn't want to be shouted at again. Mr and Mrs Hawthorn Cottage didn't say much. In fact, they said nothing at all, just nodded and pointed to the hedge. I measured it several times: my shortest extent was now eighty-six feet nine, and the longest ninety feet three. Well, that was what I was going to tell Mr Rayer and he could make up

his own mind. Off I set again, back to the office; Ooby was now running on petrol fumes.

'Well, Mr Rayer—' I didn't get any further.

'Philip, we'll pop out there and measure it properly.'

I couldn't see how this would help as I'd already given the damn hedge more attention than it had received in a lifetime. More in hope than expectation I tried to explain this to Mr Rayer: 'But, Mr Rayer, I've already measured it every—'

'Philip, time spent in reconnaissance is never wasted,' he butted in.

So, off we set in Thunderbird IV, Mr Rayer's Triumph motor car. I sat in the passenger seat for what, in my boss's book, was a relatively uneventful journey: we only had two near major accidents and one minor skirmish. The latter occurred as Thunderbird IV ran out of steam trying to overtake a lorry ascending Fish Hill; we had to cut it up as we pulled in, forcing it off the road and into one of those 'Emergency Roads in the Event of Brake Failure', which was full of gravel. Had Mr Rayer indicated, the poor chap might have stood a chance; as it was he had no choice but to bury his front wheels up to the axles in pebbles. His reaction was predictable but, as ever, Mr Rayer was totally unaware of the incident.

It was now about two thirty in the afternoon and I couldn't see the point of my third trip of the day to Chipping Campden.

'While we're there, Philip, there's a nasty stain on one

of the bedroom ceilings. You'd better take a closer look for me.' At that moment I realised that Mr Rayer had intended to come out himself anyway. My trips had been irrelevant. Then came the lesson for the day: 'Philip, the important thing is to get the right answer for the client. Doesn't really matter how long it takes you to get there.' That put me in my place.

We knocked on the front door and Mr and Mrs Hawthorn Cottage let us in; their surprise at seeing me for the third time that day was matched only by my embarrassment. Mr Rayer explained that he wanted to take a closer look at the stain on the ceiling in the third bedroom. Off we all went, following Mr Rayer, whose method of climbing stairs was to swing his tin leg on to each step, then haul himself up on the banister. This was all going well until Mr Rayer's sixteen and a half stone pulled the rail off the wall. Without batting an eyelid or breaking step he said, 'Make a note, Philip, might be a bit of woodworm in the stair rail.' The look on Mr and Mrs Hawthorn Cottage's faces was priceless. Only Mr Rayer could get away with destroying someone's house in the course of his job.

We made our way into the third bedroom.

'There you are, Philip. That's what I want you to have a look at.' He pointed his stick at a large brown patch on the ceiling. I didn't know what I was supposed to do other than stare at the mark we were all looking at. 'No, up in the roof space. We'll have to find the access to it.'

It was unlike Mr Rayer to admit that he needed me to do something for him, but climbing into a roof space was clearly one thing he couldn't tackle.

A rather perplexed owner disappeared and came back to the landing outside the bedroom with a step-ladder and a broom. The step-ladder was for me and the broom was for him to move back the hatch to the roof void. 'I'm afraid there's no light,' he said.

Great, I thought.

'Don't worry,' replied Mr Rayer, 'I've got a torch.'

I don't know why but somehow I knew this wasn't going to be good. Mr Rayer handed me his torch, and gave me a helpful prod with his stick as I ventured into the dark roof space. I switched it on. It certainly wouldn't have brought cries of 'Put out that light' from an air-raid warden. In fact, the battery probably was wartime issue and a spent match would have provided more of a glimmer.

'Best make your way over to the damp patch and see if you can work out what the problem is.'

I inched my way forward on all fours. The floor was unboarded so I had to balance carefully on the rafters. It was pitch black and I couldn't see the end of my nose, let alone the offending stain. It was also full of feathers from pigeons that had found a home there. Quite how I would be of any help to Mr Rayer was unclear. My cry of 'I don't really think there's too much to see up here,' echoed the view of the Hawthorn Cottage's owners.

'We haven't been up there for years.'

Mr Rayer was unmoved. 'You haven't got there yet, Philip. About another six feet to your right. On you go.'

I was now uneasy. I hated confined spaces and was beginning to feel as if the walls were closing in on me. My knees were shaking and everything beneath my hands and knees seemed to be moving. There was indeed a musty smell of damp, but I couldn't work out whether it came from my trousers, which had been soaked all day, from the general atmosphere in the roof, or from the damp patch I was now surely hovering over.

Suddenly there was a loud crack and all was light again. I felt myself falling and adopted the crash position recommended to passengers of airlines and Mr Rayer's car. I hit the soft bed below with an almighty thud. The ceiling had given way.

'Ah, thought so, Philip. Damp. We'll put that in the report too.'

Mr Rayer broke all records for a man with a tin leg going down a flight of stairs. I was hot on his heels, looking like I had been tarred and feathered with pigeon plumage and damp plasterwork. Mr and Mrs Hawthorn Cottage were speechless as Mr Rayer and I bade them farewell and made our way to the waiting Thunderbird IV. As we climbed in he shouted across to me, 'I think we'll say the hedge is eighty-eight feet, Philip.'

As we drove off, I could have sworn a grin came over his face, rather like a naughty schoolboy. Then he was preparing to light his pipe. However, the events of the day had convinced me that surveying was not for me.

Chapter Three

Counting Sheep

Bloody sheep!

Livestock in general and sheep in particular seem to have had an impact on my infant auctioneering career. And one warm evening I was standing in the middle of a field counting the little woolly devils. I was sure that the last time I had done this was when I was about ten and unable to sleep; my father had been adamant that it was a quick-fire remedy for a youngster's insomnia. Well, it hadn't worked then, and it most certainly was not proving a soothing occupation now. Occasionally when I was working with Mr Rayer, time seemed to acquire a whole new elasticity and a single hour took three to pass. It was now nearly a quarter to eight on a Friday evening in July and any self-respecting twenty-three-year-old should have been in the pub, not in a twenty-acre field surrounded by more lamb chops than a nationwide chain of butchers could cope with.

'You tally the yows and I'll look after the tegs.' At

least, that was what I think my one-legged employer shouted at me.

Anyone with half a brain would have kept quiet, guessed that there would be roughly half and half of whatever 'yows' and 'tegs' were, then counted the lot and divided by two. The only problem being, of course, if that guess was incorrect. I was sorely tempted to but knew I would immediately feel guilty, even in the unlikely event that I could have been right. Mr Rayer was unstinting in his enthusiasm to educate me in the ways of the country auctioneer. There were no shortcuts for him, so there should be none for me.

'Pardon, Mr Rayer?' I asked, dreading the response before he had even opened his mouth. Time meant nothing to my boss. If it was light you worked, and if was dark, well, you probably still worked. To Mr Rayer, the client was all important and the call of the pub was nothing like as strong to him as it was to his young trainee. The problem now was that, having asked the question, I knew I would be treated to a detailed – i.e. long – explanation when all I wanted to do was complete the task in hand, not that I was really sure what that task was.

'Well, Philip, in the west of the county they're known as hoggets while in the south . . .' It was ten to eight now. My concentration and interest were waning. I knew it would be at least another half an hour before we could get on. It was late, I was tired and, having the attention

span of a gnat, knew it wouldn't be too long before I was day-dreaming.

I had landed on my feet with my new employer, but there were drawbacks. Money was short and my social life was verging on non-existent. I had given up a career as a PE teacher earning about sixty pounds a week to train as an auctioneer and valuer earning roughly twelve pounds in the equivalent seven-day period. The one big salvation to my pocket had been my cricket on a Saturday. It was not so much that I enjoyed playing, although I did, but that I was paid travelling expenses, which, in my precarious financial state, were a lifeline. I played for the first team in the top division of the prestigious Birmingham League and the expenses roughly doubled my weekly wage, providing the all-important money for a pint of beer and a gallon of petrol (or was it a gallon of beer and a pint of petrol?). I wasn't really good enough to play at such a high level and I had feared I was about to be dropped from the team when Mr Rayer had unwittingly intervened.

He was still talking about the sheep we were counting for a farm-stock valuation and the sorry circumstances of my cricketing demise flooded back to me. Mr Rayer had arranged a run of sales on Saturdays; weekends were not a consideration for him as the days merged together – like day and night – and, being a trainee anxious to prove his worth, I was keen to attend and help out. With my cricketing commitment, sale days were always a fretful

time: would Mr Rayer sell all of the lots in time for me to get to the match? So far I had been lucky and we had always finished in time, but sooner or later I knew it would go wrong.

Before that fateful day I had asked Mr Rayer how many lots there would be in the coming Saturday sale. He had handed me the sale sheets so that I could look for myself. The last showed the final eight lots, ending at the bottom of the page with lot 114. The sale was due to start at ten thirty, which, with Mr Rayer's idea of punctuality, would be about a quarter to eleven. If we averaged a steady eighty lots an hour I would be ready to take my place on the field of play in good time.

When sale day arrived, I was feeling in control. What I had failed to take into account was the dreaded Rayer 'A' lot. When an auctioneer lots up a sale he starts, not unnaturally, at lot one and proceeds until the last item is numbered. When an extra lot is discovered it is put into the sale as an 'A' lot; very occasionally when two lots are discovered there might also be a 'B' lot. With Mr Rayer, life was a constant source of discovery. If I had taken the time to look through the sheets before the sale I would have seen that we had Lot 10, 10A, 10B, 10C, 10D – and not just here and there but on almost every lot. Horror of horrors, we even had a lot 77AA – the Galloping Major had worked his way through the alphabet and still found extra lots to slip in. The reality was that instead of the 114 lots I thought we had, there were closer to 400, and

Mr Rayer never kept to a steady eighty-lot pace through-out a sale: that rate was more his finishing sprint. (Most auctioneers will sell at a minimum rate of 100 lots per hour and, more likely, will come closer to 150.) I knew I was doomed and resigned myself to being seriously late for the game.

It was nearly five thirty when I eventually arrived at the cricket ground, having missed all of the first innings when we were fielding, and most of the second innings when we were batting. The problem with the first innings was not that my bowling had been eagerly awaited but that I was the team's wicket-keeper. When it was our turn to bat we had suffered a collapse at the hands of a wily former first-class slow left arm bowler. My arrival did not halt the opposition's progress in any way: I was caught second ball. I saw the captain bearing down on me and thought it best to get my resignation in before he could open his mouth: I had told him I needed to concentrate on my new career.

I was miles away when Mr Rayer's voice jerked me back to reality: 'Got that, Philip?' He had explained all the regional terms for what, I was later to discover, were boy and girl sheep, and I hadn't heard a word.

I looked at my watch: nearly twenty-five past eight. There were eighty-five sheep in the field and it had taken Mr Rayer and me an eternity to count them. As I was now no longer playing cricket I had a whole two days to myself, but no money to do anything. I was happy with

my working life, even though my financial state was as perilous as that of a third-world country and my love life made a Trappist monk's look rather exciting. Still, the hours I worked with Mr Rayer meant there was little time left for spending money, and if I had had any spare cash there was no young lady to entertain. Fortunately I had been lucky to find an employer who was willing to put up with a trainee for ever asking questions. This not only went for Mr Rayer but his fellow partners and all of the other staff with the firm.

Monday morning and back to work. 'Philip, you'd better pop out and lot-up doings's sale for Saturday.' I nodded, feeling quite proud of myself. Now I knew that 'doings' was Edward Hendall, a local gentleman-farmer who had made a huge amount of money selling his Birmingham-based business, which made plastic widgets and washers. The proceeds, which had, by local repute, run into eight figures before the decimal point, had financed the purchase of a huge country estate close to the Malvern Hills. He had invested a colossal sum in Brittley Manor and created a pheasant shoot that was the envy of every sporting gent in the county. To be invited to shoot with Edward Hendall was a sporting and social highlight.

The trouble was that Mr Hendall had discovered, like many before him, that the sporting ways of the country gentleman do not come cheap. This had led him to sell all of his game-rearing and shoot equipment. Mr Rayer was

the man to whom he turned, which gave my boss an opportunity to pull out all the stops to impress an important client. He decided not to conduct the sale on his own but to enlist the help of Clifford Atkins and Malcolm Hodges, who were partners from the Worcester and Malvern offices respectively. Both were accomplished auctioneers.

I arrived at the shoot lodge on the Brittley Manor estate at about ten thirty to find that all sorts of weird machinery and equipment had already been put out into rows by Silas Farrell, the estate gamekeeper. It was rather bizarre that he should have taken such care over an occasion that would surely result in his redundancy. He had a huge team of helpers, which meant that the only personnel Mr Rayer had to supply other than me were the dynamic duo: Windy Williams and Dai. The pair duly arrived in Windy's Austin 1100; and quite a spectacle they made. The reputation of the little 1100 travelled before it and, indeed, this was the first time I had set eyes on it. It appeared that Windy had decided to customise his car before the term had been invented. I had a job to believe my eyes. I had always been an admirer of the Morris 1000 Traveller and, in particular, liked the look of the timber applied to the rear half of the estate car. Imitation being the highest form of flattery, Windy had decided to copy the great Morris design by attaching lengths of inch-thick roofing baton to the car by means of self-tapping screws in the bodywork. The

timber had been carefully treated with creosote, some of which had unfortunately run down the coachwork, and finished with a bright black gloss paint.

Windy and Dai were both in their sixties and had worked for Mr Rayer for many years, at the market and setting up sales. Mr Rayer, a charitable man, rewarded loyalty over productivity.

I still hadn't got used to Windy's problem, the one that had given him his nickname, and was horrified, when he climbed out of the car, to hear a terrific ripping sound. I thought his coat had caught in the Austin's door lock and torn off the sleeve. It was only when Dai, sitting in the passenger seat with an expression of disgust on his face, made reference to Windy needing medical help that I realised it was not a material problem. Dai emerged from the car with a copy of the *Racing Post* in one hand and an unopened bottle of cider in the other. It was good to see them but I wasn't sure if we needed any help, and if we did, I wasn't convinced that they were the ones to provide it.

They took the view that it was a poor job that wouldn't stand a foreman or, in this case, two foremen. They started to walk round the sales field, giving Silas's team, who were doing a marvellous job, the benefit of their experience in the auction world. My role, as ever, being the boy with the college education, was to enter the lots on the sale sheets. Conscious of the last, infamous, cricket-match sale when Mr Rayer had

managed to turn 114 lots into nearly 400, I strove to ensure that we didn't omit any item that might be considered a potential 'A' lot. Silas's team of six were working like a well-oiled machine – in fact, not unlike an army of beaters on a pheasant shoot. The rows of lots were gun-barrel straight and we were well ahead of schedule. They were a cheery, hard-working bunch and from across the whole social spectrum, and not one was addressed by his real name. Jake was the leader of the group. His nickname, apparently, had nothing to do with a shortening of his Christian name but was a reference to the copious amounts of scrumpy cider he could consume; it was known locally as Jake. He and Dai soon struck up a relationship.

While Dai distracted him, I found myself chatting to Silas's next man in line: a young fellow of similar age to me. Everyone referred to him as 'Plank', which I thought must be some sort of shortening of his surname, until he told me his name was Jacobi Nell-Grady. Well, I could see that a name like that needed shortening but, to a simple chap like me, Jack seemed the obvious answer. Eventually I discovered that his nickname had been bestowed by Jake who maintained that he was just like a plank because he simply was as thick as one. Rather worryingly, he was due to take up a place at Sandhurst to become a full-time army officer. He was impeccably dressed, starting at the top with a flat hat in which he had moulded a razor-sharp ridge running from back to front. His Barbour was the only one I had

ever seen that had been ironed, and an old-school tie from a minor Devon public school poked out of it. Next came checked plus-fours, so loud they would have screamed at you in pitch darkness, and finally a pair of green Hunter wellies, which looked as if he had polished them. When his cap was removed a shock of bright ginger hair was revealed which looked like it had been attacked by a blind man with a Strimmer – it wasn't just a short-back-and-sides, it was short-back-and-everything. He called everyone 'sir' and behaved almost like someone out of a *Monty Python* sketch. I swear I saw him salute one of the many black Labradors that were wandering around the place. Plank, bless him, was the butt of everyone's jokes: while I lotted up the sale I lost count of the number of times he was sent by a colleague to get a left-handed screwdriver or a tin of tartan paint. I can't deny, though, that it was of some concern to me that, in the event of military conflict, our nation's safety might rest in his hands.

The sale comprised everything that a well-organised commercial shoot would own. There were incubators and hatchers for seemingly infinite numbers of young pheasant and partridge, wire fencing by the mile, a forest of wooden stakes and rolls of netting, rather like fine tennis nets, which would have been used around pens to keep in the pheasants. Thanks to Silas, we were well ahead of schedule for the sale on Saturday and, for once, I was relaxed, not worrying about where I would have to be in the afternoon to play cricket.

As ever, Hinge and Bracket, as I had dubbed the two admin ladies (who reminded me of the characters who appeared in the eponymous television show at that time) back in the office, had worked miracles in terms of advertising and getting people to the sale, and come Friday afternoon, even though viewing did not start officially until Saturday morning, there were crowds of potential bidders examining what was on offer. I began to experience the quiet confidence an auctioneer feels when he knows he's going to have a good day. Plank was in his element: he had never had so many people to call 'sir' before, and he was walking about happily with a clipboard under his arm and his shiny green wellies reflecting the sunlight. I was supposed to be showing him what we wanted him to do and had asked him to look after the commission bids: I reckoned he could do the least amount of damage there. These were absentee bids, left with the auctioneers by people unable to attend the sale in person; the auctioneers would bid on their behalf. Plank turned out to be really quite efficient and, in true military fashion, was very thorough in making sure that all of those bids made it on to the sale sheets so that the auctioneer could bid on the correct lots. We all left Brittley Manor full of optimism for the day ahead.

The next morning I arrived early at the sale site to find crowds that would have filled a modest football stadium several times. Windy, Dai and I had a quick meeting in Silas's office to decide on our tasks for the day. It became

swiftly apparent that Windy and Dai would have no responsibilities and that everything would fall to me. Plank was anxious to be involved and we decided that he should remain in the office in charge of the commission bids: i.e. out of harm's way. Clifford Atkins and Malcolm Hodges were around, but Mr Rayer had yet to arrive. There was still an hour before the sale was due to start so I decided that all was well and, leaving Plank in charge of the phone, went off to make sure that Windy and Dai could identify all of the lots when the time came to sell them.

I had only been out of the office for about ten minutes when Plank came rushing towards me. 'He's broken his leg! He's broken his leg!' he shouted.

'Who has?' I asked.

'He has,' came the response, from the man who was about to honour our finest military academy with his presence. Eventually I extracted from him that Mr Rayer's wife had been on the phone and my boss was the victim. Furthermore, he was unable to make the sale.

Concerned, I plucked up the courage to telephone Mrs Rayer: she was a local Justice of the Peace who, to an irreverant few, was known as the hanging judge. 'How's Mr Rayer?' I enquired tentatively.

Calmly – over-calmly, I thought, as he must have been in some pain – she said, 'Well, he's broken his leg. It's his own stupid fault. He was trying to open a window with a stepladder and a broom. I've got no sympathy.'

I thought this a little harsh, to say the least. 'Is he all right?' He was in pain every day of his life, and while he was probably not the best patient in the world he was not one to complain of discomfort.

'I was supposed to be playing bridge this morning. It's very inconvenient.' Not too much compassion there. 'It nearly came off completely at the knee – it was just hanging there.' I gasped. He must in terrible pain, I thought.

'He's normally got a spare but that's broken as well, so I'm afraid he really is grounded.'

'Pardon?' I was really confused now.

'For heaven's sake, he's broken his false leg!'

Rather sheepishly, I tried to pretend that I'd known all the time what she had been talking about. 'He's adamant that someone should be by the phone in the keeper's office so that he can keep up with how the sale's going. He said to get that army chap on the job.'

Plank was overjoyed at this confirmation of his responsibility and stationed himself within a foot of the phone with my instructions to make sure that any new commission bids were put on to the sheets and to keep Mr Rayer fully informed of the sale's progress.

With the Galloping Major out of action, the sale was conducted by Messrs Hodges and Atkins. All of the lots seemed to be making well in excess of Mr Rayer's anticipated prices, many being sold to the commission bidders, and everything was progressing without a hitch

as the sale came towards a highly successful conclusion. One of the last lots was the netting from around the pheasant pens. The sale sheets showed Mr Rayer's estimate of £20–30 and then, in Plank's neat, precise handwriting, three commission bids: Mill Ground Shoot £210, Eric Jennings £270 and finally M. Durayor with the word 'BUY' next to the name. This meant that if no other party bid, the lot would make £280 (thus topping the next best bid of £270 that Jennings had left), but if there were other bids we were to continue bidding until M. Durayor was successful. (These days, no auctioneer should accept a 'buy' bid: they really are a recipe for disaster.) The hammer eventually fell to M. Durayor for £420 – way over my boss's pessimistic estimate.

At the end of the sale we gathered in the keeper's office in good spirits. It was time now to contact the commission bidders whom Plank had dealt with to let them know what they had bought and for how much. Surprisingly, there were no errors – until we came to the netting.

'Who's this M. Durayor, then, Plank? Got a phone number for him?' This brought a rather blank look from the future military mastermind. I repeated the question.

'Are you joking? He's your boss,' Plank replied.

A sudden, horrid dawning of realisation swept over me. 'Plank, is this Mr Rayer?'

'Well, yes. Major Rayer was on the phone every ten lots or so. Said he knew the estimate for the netting and

would I try to buy it for him. Wanted it to cover his raspberries from the birds.'

Mr Rayer had never been known to spend more than about thirty-five pounds on a lot so this was going to be a rather nasty surprise for him.

Clifford Atkins came up with a plan that everyone seemed to be in favour of: 'Philip, you'd best phone him.' He walked off.

My conversation with Mr Rayer went something along the lines of 'Mr Rayer, thought I'd better give you a call. You bought that netting. Really busy just now. See you on Monday.'

'Hold on, Philip, how much was it?'

'Well, Guv'nor, we had a really good sale and it's difficult to hear right now but I'll see you on Monday.'

'Philip, how much was it?'

I mumbled and coughed. 'Er, about [cough] a hundred pounds.'

'*HOW MUCH?*'

It was no use. 'Four hundred and twenty pounds, Mr Rayer.'

There was a long pause.

'Fruit's going to be a bit dear this year.'

Chapter Four

Old Mothers Doings

'Philip, meet me at Settlebank. We've got to go and see old Mother Doings,' came the familiar voice down the line.

I didn't bother to enquire about the whereabouts of or, indeed, who 'old Mother Doings' was. All of that would become clear in the fullness of time. Settlebank, on the other hand, was the Rayer family home and reflected the character of its owner: it was most definitely lived-in, somewhat frayed around the edges and unique. It stood in six acres of land with stables, orchards and paddocks, and had been occupied by a Rayer since it had been built around 1830. Occasionally cattle or sheep were to be seen grazing in the meadow in front of the house. There was nothing unusual about that: such rural scenes were familiar throughout the county (indeed, throughout the country). The big difference between Settlebank and all the other similar smallholdings, however, was its location: Settlebank

was not a rural idyll – it was right in the middle of Worcester. All of the city's landmarks – the main shopping centre, the cathedral, the porcelain factory, the cricket ground and the racecourse – were within walking distance of the Rayer home. It was a large, six-bedroomed house. On the ground floor there were steps and little half-landings that took you up and down to rooms that appeared as if by magic. The dining room was large and airy, with light-painted wooden panels, one of which was very special: this was the one on which every member of the Rayer family had had their height measured each year on Christmas Day, going back to when the family had first moved in all those years ago. By the side of each mark was their name and date of birth. It was interesting to see how some family members had shot up during the twelve months separating each Christmas – and how often the name Hobbs appeared; it was, of course, Mr Rayer's link to the firm, Bentley, Hobbs and Mytton. Mr Rayer had left his mark not only in the dining room but throughout Settlebank. He had achieved this with little effort. Maintenance, decoration and general upkeep were not part of his grand plan. His father had had terrific success as a champion rose-grower. It was not hereditary. Mr Rayer viewed gardening and DIY in the same way: it was best not to meddle, and to leave well alone. The once magnificent rose garden was now, stem by stem, slowly reverting to nature.

I felt sorry for Mr Rayer's wife, Peggy, though she was more than a match for her husband. She was a stout lady with an opinion on most things, very much in the Margaret Thatcher mould. The three Rayer children, Margaret, Jayne and William, were real chips off both blocks; all were then middle-aged and had long since flown the nest. Mr and Mrs Rayer were devoted to each other and to their children, but conversation between them appeared to be by osmosis; a ouija board would have been more responsive.

The drive to the house swept from a small cul-de-sac at the rear to the front, with the house on one side and the fields on the other, which were normally home to his stock. When it came to cattle and sheep Mr Rayer's judgement was the envy of his peers. His own stock, however, failed to reflect this: he ran the animal equivalent of a home for waifs and strays. His purchases were impulse buys – the impulse being sympathy. Mr Rayer was a sucker for bidding on lots that no one else wanted. It didn't matter what he was selling, he always felt obliged to open the bidding. This was fine when he was selling a good lot and the audience bid too, but when there was only one bid it was invariably Mr Rayer's: he had the finest collection of anorexic cows, rusty barbed wire, three-legged chairs and handleless cups that the world would ever see.

As I drove into Settlebank I noticed there were no stock in the pasture; it appeared that my boss had decided to

plough it, probably for the first time in more than a hundred years. What was even more unusual was the *way* he was going about it: his old Triumph was making its way slowly along a roughly ploughed ridge in the middle of the field. A second glance revealed that Thunderbird IV was responsible for the furrow: Dai was crouched in the boot making sure that the plough lashed to the rear bumper by lengths of flex and rope stayed fixed. I watched this pantomime for about ten minutes before Mr Rayer saw me and turned the steering-wheel in my direction. This caused the flex and rope to snap. Dai tried to grab the now free plough, and catapulted head first into the middle of the furrow. Mr Rayer, oblivious to this, pulled up beside me on the edge of the field. 'What brings you here, Philip?' he asked.

It was time to state the obvious. 'We've got to go and see old Mother Doings,' I replied, quoting our earlier conversation.

'Philip, if you're going to make it as a professional, it's no use talking in riddles. You've got to make yourself clear.'

I was glad we'd reached an understanding. 'Hop in,' he said, and off we went, leaving a soil-covered Dai in the middle of the field with a useless plough at his feet.

'Where exactly are we going to?' I asked Mr Rayer, as his pipe came out and the car filled with smoke, the smell of spent matches and burning clothes.

'She lives at Gilbert Manor, the other side of Stow,' came to me through the smog.

'Stow' was Stow-on-the-Wold in the Cotswolds and, in due course, we arrived at the gate of an impressive residence. As the old Triumph made its way up the gravelled drive a glorious mellow Cotswold-stone manor house appeared in the distance. Gilbert Manor was imposing. The windows had heavy stone mullions to the grand elevations and the whole was topped off with smoke-blackened chimneys. As the name 'Manor' implied, it was a huge old pile and must have had at least ten bedrooms. It would have suited the pages of *Country Life*, surrounded by specimen yew trees that had been clipped to form a classic country-house topiary. However, when we pulled up at the front door of the house, it became evident that old Mother Doings, whose real name I still did not know, had been to the same school of home maintenance as EEFR. I went to tap the huge brass knocker on the front door only for it to come off in my hand.

But old Mother Doings, whoever she was, must have heard us arrive as she was now on the other side of the door. 'Better come round to the back!' she bellowed.

I looked for the non-existent doorknob, which had obviously fallen off years ago, and could see that there was no way to open the front door, so I followed Mr Rayer to the back where we were greeted by old Mother Doings.

'Philip, this is Mrs Hall-Dants.'

She was a lady of ample proportions whose knee-length skirt hung round her waist like the curtains in a crematorium. Bizarrely, this massive structure was supported on legs as thin as pipe-cleaners. 'Follow me!' she boomed, as Mr Rayer and I went into the house. 'Ted, you wait here while the young man and I go and look at the sheep.' Not many people dished out orders to Ernest Edward Foley Rayer; Mrs Hall-Dants was some lady. 'You can talk to my husband,' she added, and at that moment in he walked.

I couldn't stop myself doing a double-take: he was barely the size of one of her skinny legs. His waist must have been less than thirty inches and he was about five feet eight tall. His hollow cheeks hid behind a big grey walrus-like moustache and his complexion was the colour of flour. He would have made a corpse look healthy.

My boss stood there like a schoolboy being given a detention by his stern headmistress; after a while he sat down and was joined by Mr Hall-Dants. Neither said anything. I was more concerned by the dreaded five letter-word – sheep. I was fed up to the back teeth with them.

'Come on!' she commanded, and I followed her along a passage. We made our way up a flight of stairs and along a landing to a door that was clearly locked. 'We need to go through my bedroom,' she said, taking two

keys from her pocket to undo the padlock and a Yale
lock. I chuckled quietly to myself as I tried to work out
whether the locks were to keep her husband in or out.
Her bedroom was surreal: wonderful antique furniture
stood everywhere, including a four-poster bed, and a six-
inch-deep carpet of her clothes was strewn across the
floor. It looked as if she had just been burgled. There was
a second door at the far end, which she opened to reveal a
set of steep stairs that went up into the attic. I was feeling
a little confused; why would we go into the attic to look
at sheep? Presumably they were in a field we could see
from a window up there.

'Follow me and don't dally!' Mrs Hall-Dants was not
shy about giving orders and off she set up the steps in
front of her, which were more like a ladder than a
staircase.

After about nine steps, I looked up. It was like an
eclipse of the sun: a huge pair of white bloomers
confronted me, about twelve inches from my eyes.
The rest of the ascent was difficult: I tried to go up
looking at my feet. There was one particularly embar-
rassing moment when, eyes glued to the step below, I
head-butted her bottom because I hadn't realised she
had stopped. I'm not sure that she felt it – I thought I'd
gone into a wall.

Eventually we got to the attic. My boss's client was
now glowing with exertion. I picked my way across the
floor, which was strewn with possessions that were no

longer wanted on the lower floors, to the window and tried to peer out at the flock.

'There we are,' she said. I could see nothing from the window, and Mrs Hall-Dants appeared to be looking at the floor. 'What do you think?'

I was baffled. I still couldn't see any sheep. Then, taking me by surprise, she picked up a painting from the top of a pile on the floor. It was an oil of nine sheep in a cliff-top landscape. It appeared to be nineteenth century and was about eighteen by twenty-four inches.

'I hate wretched sheep!' She was obviously a lady after my own heart. 'Been in the family for three generations, but I can't abide the little bleaters. It might as well go.'

She handed me the picture, expecting me to pass some sort of comment. I was just relieved that the animals were on canvas and not the real thing. 'I think we ought to show it to Mr Rayer,' I said, and made my way back to the staircase.

'You go first, young man – best to go down backwards. Don't want you falling with my painting.'

That was not good news. She was obviously more used to her staircase than I was, so she went down a lot quicker than I could. Her bottom kept hitting my head like a pile-driver, but she seemed not to notice.

When we got back to the kitchen, Mr Rayer was sitting talking to Mr Hall-Dants. As soon as we came in Mr

Hall-Dants stopped talking, stood up and melted into the background.

I handed the painting to Mr Rayer and Mrs Hall-Dants told him she wanted to sell it in the next sale. We bid our farewells and made our way out to the old Triumph. We had to reverse to turn the car round, always an interesting manoeuvre with Mr Rayer. He moved the gearstick to 'R', for reverse, then floored the accelerator. As usual nothing happened immediately: the gearbox and the engine needed time to think about what they were being asked to do. Then, without warning, they lurched into the selected mode. Mr Rayer was not a great one for looking in his wing or interior mirrors or, indeed, turning round to look out of the rear window. He simply backed the car until he had gone far enough or until he hit something. This time we struck a stone pump trough, which brought us to an abrupt halt. As was now normal, neither Mr Rayer nor I said anything: there was little point in remarking on an everyday occurrence. It was just another dent on another dent on the much-abused car.

The sale for the little painting was in three weeks' time, and Mr Rayer's view on what it would make was fairly predictable: 'It'll make what it's worth, Philip. We'll put an advert in the trade paper and that will bring all the dealers in.' (One of Mr Rayer's older trainees once told me how in the 1950s his boss had catalogued a painting

in a house sale as 'A. Canal – oil painting: A Venetian Scene.' Mr Rayer had placed an advert in the trade paper of the time and was staggered by the response. He was more interested in cattle than canals and had not appreciated that A. Canal was Canaletto's real name. I never found out what it sold for but have always wondered if it 'made what it was worth'.)

The sale day came and the sheep painting attracted a lot of interest from many collectors and dealers, but in particular a local man, who was very quiet and never used ten words when one would do. He was about five years older than me, immaculately dressed with thick-rimmed spectacles. In an age when everyone smoked, I was impressed that he only ever smoked the first third of a cigarette and threw the rest away. I could never have afforded to do that. I asked him what he thought of the sheep picture.

'OK.'

I waited in vain for more.

'Is he an artist you know?' I asked. 'Is this a typical subject?' I added hastily.

'Charles Jones. Paints sheep.'

I tried to further the conversation and met with a wall of silence. It was not that he was obstructive, he simply did not talk very much. (It was a response I was to become used to over the years as he became a friend and adviser known simply to all as the Picture Man.)

He was the successful bidder at the sale, paying £4400 for the painting. As he collected it I asked him what he thought of the price. Without looking up he replied, 'About right. He normally makes five hundred pounds a sheep.'

Chapter Five

A Very Unusual Piece

'Philip, we're off to the Malvern office to see Mr Hodges.' He was the senior partner in the firm, known as 'Big Mal' to all and sundry but, naturally, this was not a nickname that Mr Rayer would have used with a mere trainee such as myself. Malcolm George Henry Hodges was a Fellow of the Royal Institution of Chartered Surveyors and just about every other body allied to our profession. He was six feet tall with silvery-white hair, always immaculately dressed, normally in the kind of suit only available from those gents' outfitters that had yellowing Cellophane in the window. That is not to say his clothes were cheap: it was just that they were of a cut that would not have looked out of place in a Stewart Granger film.

The journey to Malvern was even more nerve-racking than a normal trip with Mr Rayer. His old Triumph was due for a minor makeover at the local garage. He always tried to use local tradesmen, which I thought

commendable; it was only as time passed, however, that I realised most of the locals had served with, or under, him in the army, and many weren't that skilled in their Civvy Street occupations. The garage man was a case in point. Judging by the repairs that he had carried out on Thunderbird IV in the past, his army career had been more demolition than construction based. After his ministrations the Triumph, which had begun life in a shade of rich yellow, had taken on the appearance of a camouflaged desert Land Rover. However, as in all areas of his life, Mr Rayer supported those who had supported him, and loyalty to old comrades was unquestioned, on his part and theirs.

Due to the incapacity of the Triumph, I had to drive my boss in my little red Mini. Mr Rayer was a back-seat driver; the level of driving he expected from all who chauffeured him was inversely proportional to his own skill. We didn't start off too well. Mr Rayer nearly pulled off the passenger door as he balanced his entire frame on it while he got in. I was sitting in the driver's seat and cringed as I watched the door frame buckle under his weight.

'Can't seem to get this door to shut properly, Philip. Might have to get my man to have a look at it for you.'

'No, it's all right,' I blurted, rather too quickly, realising at once that I had probably sounded a little rude and ungrateful. I got out of the car and slammed Mr Rayer's door as hard as I could, in the hope that somehow it would go back into shape. Off we went.

'*Look out – there's a car!*' bellowed EEFR, before I had even turned the key in the ignition. A constant commentary continued throughout the ten-mile journey and my nerves frayed, but at last we arrived in the Malvern office car park and I could turn my attention to opening the door I had wedged shut on Mr Rayer.

'You really ought to get that fixed, Philip. It should never be quite that stiff.'

Malvern is a strange place with, I swear, its own climatic conditions. There were days when I had been walking along the ridge of the hills with the sun shining five paces to the eastern side while five paces to the west there was rain, hail or snow. Today was one of those days: the sun had bathed Worcester in a golden glow when Mr Rayer and I left the office but heavy cloud was forming on the far side of the hills.

While the Galloping Major was seeing Big Mal, I was to go and inspect an item that might come up for auction. It was a rare solo flight for me and I was determined to do a good job and impress both EEFR and MGHH – Big Mal was known by his initials too. Mr Rayer's parting shot as I left the office was 'Philip, he's got a piece of silver he wants to sell. It'll be good experience for you to deal with and catalogue it.'

John Walker Thornton Jones was the client's name. To me it implied a man of some substance and undoubted breeding. I drove off to the western side of the hills and, as I passed through the Wyche Cutting, the sky became a

dense white blanket and snow began to fall. The address Mr Rayer had given me was Orchard Farm, Coddington, Near Malvern. I imagined a rather grand farmhouse where the Thornton Joneses had been resident for several generations. I was sure he would be a professional businessman, almost certainly a lawyer or an accountant. His practice must be in Birmingham as his was not a name I was familiar with in Worcester or Malvern. As I drove on I conjured up a picture of him: he would be a dapper man in a smart, deep blue pin-stripe suit, with a shirt as white as the freshly falling snow. A regimental tie would reveal his Sandhurst background. I was brought sharply back to reality as my little red Mini headed for a ditch. I grappled with the steering-wheel and succeeded, in true rally-driver style, in getting back on track. Time to concentrate.

Negotiating the narrow lanes was tricker than normal, due partly to the light covering of snow and also to the assault on my driving ability from EEFR, which had left my confidence as low as a dachshund's tummy, but eventually I pulled into the yard of Orchard Farm. I have to say I was a little disappointed: *House & Garden* it was not. It was clearly not a working farm, or that of a gentleman: it was generally run down with no sign of animals, machinery or any recent maintenance.

As I was getting out of the car a huge character appeared from around a corner. He was about six feet four and must have weighed close to twenty-five stone;

he was nearly as wide as he was tall. His dress was not that of a Birmingham professional: he was wearing a pair of jeans with his bottom hanging out and a pair of once-suede Hush Puppies with no nap. More extraordinary still was his shirt. It was a Tattersall check under immense pressure from his girth and, bizarrely, had a red flannel gusset fitted front and rear. This could not have been a manufacturer's design feature, but an after-market adjustment to squeeze a quart into a pint pot – or, in this case, several quarts.

'Mr Thornton Jones?' I queried.

'Jones is the surname – John Walker Thornton was my mother's choice of Christian names. Apparently she liked whisky and chocolate before I was born.'

From the size of him, I assumed they were tastes that had passed on to the next generation in spades.

'Did Ted tell you what I wanted?'

Short and to the point.

'Yes, sir. He said you wanted to sell a piece of silver.'

'Well, young man, I hope you're up to it. I'm not sure I want someone inexperienced like you to deal with it.'

He didn't mince his words either and, anxious that I might lose the job, I butted in: 'I'm sure I can do a good job for you. I'll put plenty of time into cataloguing it properly.'

'But you look a bit wet round the ears to me to be dealing with a potentially important piece of silver . . .'

Our whisky-drinking chocolate lover didn't seem to

have much confidence in me. Nor did he mind on whose corns he trod.

'Look, why don't you let me take it back to the office? I'll let you know what we think.'

'Well, I hope it's not a case of a boy doing a man's job. It's got a hallmark on it, "*HB*", which I think might be one of the Batemans. Still, you're the expert. I'll leave you to research and catalogue it. I'll go and get it from the house for you.'

When he turned his back, the red gusset on his shirt looked like a slash of blood. I waited by my car, surveying the damage that had been inflicted on the passenger door: it either fitted at the top or the bottom but unfortunately not both at the same time.

'Here you are, young man. You do a good job with it and make sure you research it properly.'

He handed over an old, battered cardboard box with the piece of silver inside. I peered in and saw the outline of an elongated oval bowl with a clear glass liner. I decided not to open the passenger door, which I thought now had a limited life span, and placed the box on the back seat through the driver's door. As I drove out of the yard the snow stopped, and I made my way back to the Galloping Major and Big Mal beneath clear, sunny skies.

I parked outside the office and walked to the building. I had just started to push open the rear door when I had a sudden attack of panic. What if someone forced open the

dodgy door of my car and stole the silver while I was in the offices? The firm would have to pay Mr Thornton for it. Mr Rayer had been quick to tell me: 'Never leave goods in an unattended car. Invalidates the insurance.' I went back to the car, grabbed the box and, clutching it to my chest, walked back into the offices. Eventually Mr Rayer came out and we returned to to the Mini. He seemed oblivious to the old brown box glued to my front like an aqualung that had been put on the wrong way round.

'Philip, you really need to sort this door out!' my boss shouted over the roof of the car, as he struggled to open it. Never a man to give in, he leaned his immense frame on it and finally forced it open. He slid into the passenger seat and slammed the door with such force that it jammed shut, although the catch did not engage. How on earth was I going to get him out when we arrived back in Worcester?

'What's that box, Philip?'

It wasn't the first time he seemed to have forgotten about the task he had set me. I reminded him of my mission to Orchard Farm, then fired up Ooby and set off, conscious that I didn't want to upset Mr Rayer with my driving. All went well until we reached the traffic lights at the bottom of the hill below the office. They were on amber and the car in front of me, not unreasonably, stopped. Mr Rayer leaned across and slammed his hand on the horn. 'Look at the damn fool, Philip! Some people

just shouldn't be on the road.' He was right, and one of them was sitting next to me.

We drove back to Worcester without further incident and Mr Rayer managed to get out of the car with surprising ease. On the journey he had told me that he was keen I should deal with the silver bowl unsupervised as he felt it was the best way for me to learn: hands-on experience, he called it. I wanted to get started straight away, so I shot into my office without wasting any time. 'Office' was a somewhat grandiose term for the little room I occupied on the third floor – it was more of an attic. The floor was covered with dead files that dated back years; most, if not all, were destined never to be opened again. Mr Rayer, however, was not a man to throw anything away and this was their current resting place. An old Ministry of Defence desk stood in the corner with a fifty-year-old prototype swivel chair. You were supposed to be able to lean back in it, but it had no stop device and therefore had a nasty habit of depositing the occupant in a heap on the floor behind it. As a result, the only safe position was totally upright.

'HB', Mr Jones had said, and something about the Batemans. It was time to get out the Bible. *Jacksons* was a book on silver that listed all the hallmarks and important makers since Noah was a lad. Basically, the little lion mark proved that a piece was silver; another mark indicated the town in which it was assayed; a letter of the alphabet in a particular type of script showed the

year; and finally a symbol or letters, in this case 'HB', was the marker's mark. It was just a question of looking up the marks in the book. I peered at the rim of the bowl where the hallmarks were: they were quite clear, with a shadow-like line round them. I thumbed through the book and, sure enough, there were the marks. The piece had been assayed in London at the end of the eighteenth century and the maker was quite clear to distinguish: 'Hester Bateman'. It was time to get out one of the price-guide books and check on the sort of money dear old Hester fetched. This wasn't proving too difficult: two hours' research and I was delighted with my results. Absent-mindedly, I leaned back in my chair, like all top executives did, as I telephoned Mr Jones. When he answered I nearly went past the point of no return and dropped the phone with a thoroughly unexecutive crash. I recovered my composure as quickly as I could.

'Have you dropped my bowl, young man?' an irate Mr Thornton shouted.

I reassured him and went on to tell him my thoughts, concluding with my opinion of value: 'Mr Jones, it could make between a thousand and two thousand pounds,' I told him proudly.

'You really do seem to have done your homework. Quite the expert. Would you put your thoughts in writing to me?'

I penned a letter for Hinge and Bracket to type up, then told Mr Rayer what I had done.

'Well done, Philip. Research and a considered value – a client can't fault that.'

I was feeling quite pleased with myself: perhaps silver was an area I should specialise in? It seemed simple.

I included a photograph of the bowl in the advert and catalogue for the sale and was pleased with the response from dealers and collectors alike. From their initial enquiries, they seemed to agree that it was an unusual piece for Hester Bateman; I was hopeful that my reserve figure of a thousand pounds would be easily exceeded.

Viewing took place on the morning of the sale, and all of the dealers made a bee-line for 'my' bowl. They picked it up and 'huffed' on the hallmarks: this makes the marks appear a lot clearer for a split second until the vapour clears. They all put it down quickly and moved on to view the other silver. This did not worry me unduly as I knew that none would want to show his or her hand. Eventually the wife of one of Mr Rayer's farmer clients made her way towards me. 'Philip, I'd like to bid on the bowl by Bateman. I don't really know anything about silver but it's so attractive.'

Feeling even more pleased with myself, I told her all about it and that I thought it could make anywhere between one and two thousand pounds, possibly closer to the latter, given the number of people who had looked at it.

'Well, I'll take your advice and have a go.' This was music to my ears.

The sale began, with Mr Rayer at the rostrum. After what seemed a lifetime we got to the bowl. The reserve was a thousand pounds so I knew it would make at least that. It was just a question of how much higher it would go.

'Bid me a thousand pounds?'

Nothing, but I had learned not to be too despondent about this. It was a standard tactic for experienced buyers at auction.

'Eight hundred then . . . six . . . All right, five's a start?'

At that the farmer's wife put up her hand. She was bidding against the reserve figure until we got to the thousand-pound mark. The bid was with the farmer's wife and still none of the dealers had come in. They were a canny lot.

'A thousand and fifty, then?' Silence, followed by, 'Yours, madam!'

Well, it had sold but I was bitterly disappointed it hadn't made more.

'Not to worry, Philip. It made what it was worth.'

About three weeks later I was sitting in my office when the phone rang. I had got over the dealers' rejection of the bowl, but only just. It was Hinge. The farmer's wife was waiting in the reception area to see me. I wandered down, thinking she must be pleased with her purchase.

'Philip, it's wrong.'

Those are not words that any auctioneer wants to hear.

'I'm sorry?'

'Philip, the bowl's a fake.'

My jaw dropped as she went on to explain that she had taken the bowl to a specialist silver dealer for an insurance valuation. He had told her the bad news. Apparently the hallmark was indeed that of Hester Bateman but it had originally been on a small spoon or fork. It had been cut out and, silver being a soft metal, beaten into a much larger bowl. The shadowy line that I had seen around the hallmark was the proof. I had initially seen the join, but hadn't realised what it meant. It was time to tell Mr Rayer.

'Get the cheque book, Philip. Best give the lady her money back.'

Perhaps silver wasn't so easy after all. I thought I had better tell Mr Thornton. It was not a conversation to which I was looking forward, but I wanted to get it out of the way. I told him the whole story and expected an angry response as I suggested he return his cheque to us. Instead he was mild – but firm. 'Awfully sorry, young man, but you're the expert and you gave me the advice on which I relied. You surely can't expect me to pay for your mistake.'

My stomach was level with my kneecaps.

Later I recounted the story to Mr Rayer, expecting a terrible cussing. I should have known better. Ever the gentleman, his tone, too, was mild: 'Well, that's a dear lesson learned, Philip.'

A Very Unusual Piece

To this day I'm not sure whether John Walker Thornton Jones knew that the bowl was a fake. Perhaps he had protested just a little too much that I research 'HB' properly . . . Was he totally innocent? All I knew for certain was that I had been had.

Chapter Six

Albert Hall

One of my many duties for Mr Rayer was to collect keys and particulars for various properties he had to inspect from the agents who held them. By and large, these were firms similar to Bentley, Hobbs and Mytton and had been in Worcester for some time, with similar personnel, including trainees like me. They were all located in the Georgian buildings around Foregate Street, so I always carried out my errands for Mr Rayer on foot. It was a good opportunity to get out of the smoky atmosphere of the office and meet up with my peers elsewhere – and, more interestingly, some of the girls.

The trainees generally shared similar misfortunes: we were all burdened with dodgy cars, no money or a complete lack of female company. In my case it was a combination of all three. If any of us was lucky enough to attract the notice of a young lady, no money and a dodgy car meant that the unsuspecting lass didn't stick around for long. Jim Johnson was my counterpart at Lloyd and

Gold, who, like Bentley, Hobbs and Mytton, carried out general-practice work. Jim and I often used to call in for a pint at my local pub, the Greyhound. The regulars, many of whom were clients of the two firms we worked for, were charitable to us both. There was a bar-billiards table in the corner of the public bar and fifty pence was the standard wager for a game. Jim and I jointly held the slow-drinking world record for consuming a pint, and on many occasions we were offered a drink by our fellow imbibers. Neither Jim nor I was keen on charity: we could ill afford to buy ourselves a drink, let alone return the compliment. The locals, unknown to us, had devised a plan whereby whenever we played them at bar billiards we won. In the innocence of youth we believed we were good players and didn't realise they were losing intentionally. It worked well until the night two strangers came into the pub and started to play. Naturally Jim and I thought, with our all-conquering ability, that victory was a foregone conclusion.

'Fancy a game, lads? Jim asked. Then, giving me a wink, he said, 'We normally play for a small wager. That OK?'

'Fine. A fiver all right?' asked the taller of the two strangers, who had now taken on the mantle of a Clint Eastwood cowboy, the one who says little but for whom actions speak louder than words.

I was twitching a bit at the thought of losing all that money – it was nearly half a week's wages for me – and

was about to feign bar-billiards elbow when Jim said, 'Great – as long as you don't mind losing it!'

I tried to stammer that perhaps we ought to have a drink first while I thought of another reason why we couldn't play, but before I knew it the bet was on and the game had begun – and ended. More to the point I was five pounds lighter. The locals were so upset by our foolhardiness that their generosity dried up for the night and we each had to make a pint last the two and a half hours till closing time. There was nothing for it but to retreat to the corner of the bar and wallow in our problems. Invariably the topic came round to the fairer sex. I was very fed up: it seemed like ages since I'd had a date. Then Jim piped up, 'I'm going for a drink with Albert on Thursday night.'

'Who the hell is Albert?' I asked. Jim was my long-time drinking partner and now he was deserting me for a bloke called Albert.

'Albert Hall,' he replied.

'Who the hell is Albert Hall?' I repeated, in as hurt a tone as I could muster.

'She's a new receptionist in the office. Started yesterday. Bloody lovely too.'

'Name's going to be a bit of a handicap isn't it? "Mum – I'd like you to meet my new girlfriend, Albert." Anyway, I thought you and I were coming here Thursday for a game of billiards.'

I was beginning to feel like I was in a scene from *The Likely Lads* with the characters Terry and Bob.

'Honest, Phil, she's a belter! Her name's really Rosemary Hall but we christened her Albert. She hasn't found out yet but she seems a good sort.' Well, at least Jim was happy but I was rapidly turning into Norman No Mates.

By the next morning my bad mood hadn't lifted. I went into the office and was quietly, or sulkily, sitting in my room up with the gods when the phone rang. It was Mr Rayer. 'Philip, I want you to pop up to Lloyd and Gold for me to collect the sale particulars for Arlington Farm. They're selling it by auction later this month and we have a client who might wish us to bid on it for him.'

Arlington Farm was part of a large estate owned by the Bridges family, one of the area's wealthiest clans. They were selling to help fund the purchase of a much larger farm closer to their main holding of about fifteen hundred acres.

I wandered down the stairs and left the office to walk the fifty yards to Lloyd and Gold. I had gone about ten when I remembered that Albert had just started work there and might be in the office. It would be a great opportunity to cast an eye over her. I pressed on, feeling somewhat brighter.

When I walked into the offices no one answering Albert's description was in Reception. I passed the time of day with one of the other, older, ladies, while I waited for the plans to be photocopied, when a door from the back office opened and in she walked. I could see what

Jim had meant: she was in her early twenties with dark hair, a trim figure and a stunning face. She looked like a model. So this was Jim's date for Thursday night – and what would I be doing? Spending it with a bunch of fifty-and sixty-year-old farmers in the Greyhound.

'You m-must be Alb – new here?' I stuttered, remembering that she was unaware of her nickname.

'Yes, my first week.' Her smile was disarming and I stood there open-mouthed. Lucky Jim. I regained control of myself and thought it best to retreat back to Bentley, Hobbs and Mytton.

The rest of the week was reasonably uneventful, and Friday arrived without any drama. I thought I'd give Jim a call to see how his date had gone. Before I could dial his number, though, my phone rang. 'Philip, I need you to pop out to Arlington Farm. I'd like you to check the buildings in the yard for me. Shouldn't take too long.'

That put paid to a call to Jim. Mr Rayer's last phrase guaranteed that the rest of the day was written off.

I drove into the immaculate courtyard at Arlington Farm and pulled out the folder containing the plan that Mr Rayer had asked me to check. Foolishly I had assumed it was going to be an Ordnance Survey plan of the area. Wrong. It was a Rayer special: a tatty bit of paper that was about twenty years old and drawn with the statutory 4B pencil. If that wasn't bad enough, my boss had used the paper for various other plans, which he had erased using a perished rubber that (it appeared) he

had kept from his schooldays. The net result was a grid of lines that might or might not have been rubbed out at some time or other. I was supposed to compare this lot with the buildings around me. Like all old farmyards, they were a mish-mash of brick walls and tiled roofs that slotted together like a jigsaw in which the tightly fitting parts originated from anywhere between the 1740s and the 1960s. I couldn't make head or tail of the plan. About the only thing I could decipher was the north point, but unfortunately I was completely unaware of where north was. I twisted the plan round as if it was a Rubik's Cube. I'd had little success with that either. Some two hours later I still had no idea of what went where and, not relishing the thought, plucked up courage to head back to the office and admit defeat.

'Mr Rayer, I'm really sorry but—'

'Where have you been, Philip?'

I was building myself up to admit the truth to Mr Forgetful when he continued, 'I've got the plans for Arlington Farm. They came with the particulars you collected this morning. I'd like you to pop them in the post to our man who might want us to buy it for him.'

Well, that was great. I'd been on yet another fool's errand. I retreated to my office to find a message from Jim to meet him in the Greyhound at six. I knew he would be full of himself after his date with Albert, and an evening of his gloating after the day I'd had wasn't very

appealing. Never hit a man when he's down. Kick him – it's easier.

I was sitting in the corner of the bar sipping a half bought with all the funds I had left when Jim walked in. He didn't look half as pleased with himself as I'd thought he might. He bought a half-pint too, came over and sat down.

'Well, how did it go?'

'Bloody unbelievable. She's absolutely bloody lovely.'

It was looking like I'd a lost a billiards partner.

'You don't seem very happy about it.'

'I took her to that new posh bar in town and ordered a bottle of champagne. She said there was really no need but I wanted to impress her. It cost a bloody fortune!'

'What happened next?'

'Richard Bridges came in. Arlington Farm belongs to his parents so I felt I ought to offer him a drink. I was going to buy him a pint when he asked the barman for a glass and poured himself some of my bloody champagne. The bottle was empty, as was Albert's glass, so I ordered another thinking he might pay for it. Instead he pipes up, 'Put it on the expenses, Jim, for selling the old chap's farm.' Not only was I now potless, but he was chatting up Albert, too, and I was feeling like the gooseberry.'

It transpired that Richard had asked Albert and Jim to go on to a club. Albert said she'd love to and tried to persuade Jim too, but as he was broke he had to say he was meeting someone else, then watch Richard drive off

with her in his flash open-top sports car. 'I tell you, Phil, she was bloody lovely. It was all going so well till that Richard Bridges appeared.'

As he drooped over his meagre drink I struggled – and failed – to think of something to say. At least I still had a bar-billiards partner.

Chapter Seven

Cumberland

I was still living with my parents, and normally left for work just as the postman arrived. On most days this was of little significance as no one seemed to want to write to me. Today, however, was different. As I was leaving I bumped into the postman. 'A letter for you today, Mr Sotheby. The Queen probably wants you to sell one of her corgis.'

It was too early in the morning for me to come up with a witty reply – and, anyway, I had to be in the office early: Mr Rayer had asked me not to be late as we had a really interesting appointment that morning. I jumped into Ooby, threw the letter on to the passenger seat and raced out on to the road, nearly reducing the local cat population by one.

I managed to occupy myself for about three miles by wondering what Mr Rayer's interesting job entailed – in fact, every job of his could have been described as interesting – but curiosity finally got the better of me.

What was in the envelope? Rather than stop the car to read the contents I tried to steer with my knees while I opened the envelope, which looked as though it contained an invitation. It did, but I wasn't able to read it as at that moment – I'm ashamed to say – the car mounted the kerb and I just managed to avoid dropping the front wheels into the ditch under the hedge. I slewed to a halt and saw that the driver behind had also stopped. I got out of the car to allay any fears he might have had for my safety. He wound the window down and shouted, 'Bloody idiot! You shouldn't be allowed on the road!' I felt dreadfully embarrassed as he drove past me, shaking his fist. The drivers behind slowed down, too, to go past and stared at me. I walked sheepishly back to my car and decided the post could wait till I arrived at the office. As we all do after a motoring near-miss, I carried on with my journey observing all speed limits and Highway Code directives to the letter. What a pity it never lasts.

Surprisingly, as I pulled in at the office, I could see Mr Rayer's battered old Triumph in the car park. For once Ten o' Clock Ted had not lived up to his nickname. I walked into Reception to be greeted with 'Come on, Philip, we're going to be late.'

I still didn't know what we were going to be late for but decided I should just retrace my steps to the car park, ready for take-off in Thunderbird IV. Mr Rayer's dress code that day was different from usual: gone were the

tweeds, brogues and knitted waistcoat, and in their place
he wore a dark suit, white shirt with black tie, and black
shoes. I reasoned, not unnaturally, that he had a funeral
to go to later. It was a form of attire that I was to see him
in with alarming regularity in the coming months. I was
amazed by how many funerals he attended; it appeared
he knew more ill people who had died than I knew
people. It was only after some two years and I don't
know how many 'funerals' that I was told by the ladies in
the office that Mr Rayer was a freemason and that this
was what freemasons wore when they attended lodge
meetings. I still had a lot to learn.

As soon as we had got into the car Mr Rayer began the
pipe-lighting ritual, smoke filling the air, burning embers
falling about – I couldn't help but notice the burns and
scorch marks from previous attempts at self-combustion.
He clearly took no better care of his funeral suit than he
did of his everyday attire.

The journey, remarkably, passed without incident as
we made our way towards the Herefordshire–Worces-
tershire border. At regular intervals Mr Rayer relit his
pipe and I sat in the passenger seat, barely able to see him
through the clouds. It reminded me of a 1950s black-
and-white Navy film, in which the captain peers into a
pea-souper through a pair of binoculars while a foghorn
sounds in the background.

'We have to prepare a valuation for the executors
of a deceased estate, the contents of a cottage where

an old lady lived. Apparently there might be some quite good things and I want you to deal with the valuation. I'll obviously give you the descriptions and figures but it will be good practice for you to write up the report.'

That made me look forward to the day ahead, especially preparing the report. About three-quarters of an hour later we arrived. Mr Rayer stopped the car in front of a gate that led into a tunnel of brambles. As I began to get out to open it he said gruffly, 'Haven't brought you along to open the gates. I can open my own, thank you.'

It was not the first time he had said this, and while at first I had thought him a little ungrateful, I had learned that it was a mark of his fierce independence. So I remained seated, watching, as he struggled with the quantity of old timber held together with baler twine and rusting wire. Having opened it, he made his way back to the car, drove the few yards through it and got out again to go through the laborious process of shutting it. The performance seemed to take as long as the journey to the cottage. We proceeded to drive on through the brambles, which appeared to be having a similar effect on the coachwork of the car as barbed wire. At last we arrived at the front door – at least, I assumed it was the front door; it was difficult to tell as the stone cottage was surrounded on the outside by a wall of brambles and gorse to first-floor level. We had to fight our way into the

house through the prickly curtain. Inside was astonishing; it was like being in a dark cavern as most of the natural light was eclipsed by the foliage outside. As my eyes became accustomed to the gloom, I detected the outlines of what appeared to be, to my untrained eye, some very good antique furniture. As ever Mr Rayer was unfazed and carried on as if we were in perfectly normal surroundings.

'Here's the pad, Philip. The deceased's name was Miss Betty Castell and she died on the twenty-third of last month.' I scribbled this down as I wanted to be spot on with my report. 'And this is Bramble Cottage.'

I didn't know whether Betty herself or someone else had named the cottage, but it couldn't have been more apt. 'Always get the client's name, date of death and address in the report, and we'll start here in the hall.'

I didn't have a problem with that, but there was a problem in that I couldn't see a thing. I had never liked carrots – perhaps that was the reason. Mr Rayer, however, seemed to have X-ray vision: he had no difficulty at all in the dim light, which I attributed to his constant peering through pipesmoke.

'Right, Philip, we'll make a start. We'll use Cumberland for this job.'

I was keen to make a start too, but couldn't see what Cumberland had to do with anything. The only thing I associated it with was sausages. What on earth was he

talking about? But before I could ask he had started. 'Right, Philip, that cricket table – MLE.'

What the hell was a cricket table with MLE? (I now know that a cricket table is a three-legged table that most people assume has taken its name from the three cricket stumps; in fact, it is a derivative of the word 'cracket', which was originally a three-legged stool.)

'Next, a Georgian doings – CUE.'

Mr Rayer referred to almost everything as a doings, but what did the four kings who reigned from about 1720 to 1830 have to do with a cue? I had to interrupt. 'Mr Rayer, what exactly is doings cue?'

'The doings over there, Philip, and CUE as in Cumberland. You really need to be a bit sharper with these reports.'

In the half-light that was straining through the brambles outside I could see an outline of a corner cupboard that Mr Rayer seemed to be pointing at. What cue had to do with it I was still none the wiser. Then it dawned on me: cue must be some sort of timber I had never heard of and it was a Georgian cuewood corner cupboard – so I wrote it down. How would I ever make any sense of this back in the office?

'Next – looks like Worcester but I suppose it might be a Derby china teapot. That'll be CUE as well.'

I was now thoroughly confused; the only thing I could be sure about was that the next item on my inventory was a teapot that might have come from somewhere in middle

England. But how could a teapot be made of cuewood? Suddenly it dawned on me what a marvellous job Hinge and Bracket made of typing Mr Rayer's reports. I would rather have tried to translate ancient Greek than work out his hieroglyphics. I always felt so inadequate if I had to ask him what he was talking about. I worked out that 'cue' couldn't be a wood but quite what Cumberland had to do with it was still a mystery. As we moved through the house the plot thickened. We stopped by a lovely primitive painting of a racehorse with a jockey. I thought it more than likely nineteenth century – it definitely looked old.

'Nice picture that, Philip. Get this down. "Racehorse in a landscape, LAD".'

Now I wasn't sure if Mr Rayer was referring to the jockey as a lad, which I thought meant something different in racing terms, or whether he was really losing patience and was calling me 'lad'. The other thing that puzzled me was that he had given me some fairly basic descriptions but had omitted any prices. I assumed that, in true Rayer style, we would make the job as difficult as possible and leave all of the valuations until we got back to the office, by which time neither of us would remember any of the different items. He would call them all 'doings' and we would be totally reliant on my very first report. No pressure there, then.

This process continued as we made our way through Bramble Cottage. Mr Rayer peered into boxes, shouted a

brief description followed by CAD, MAD and even EMU. I knew he was not a big drinker, so he wasn't drunk, but I worried that he had suddenly developed some terrible mental illness that was making him use all sorts of random phrases. And I was concerned that my first report would end up as complete gibberish.

After a while we came to a halt and my heart sank as Mr Rayer took out his pipe. It was difficult enough already to see anything, without clouds of foul-smelling smoke filling the room. There was another eventuality too, which neither I nor Mr Rayer had thought of, as red-hot embers fell from the pipe on to some paper on the floor. It was only a gentle glow at first but it got brighter as flames took hold. It would seem that my fate was decided: I would be burned to death with a one-legged auctioneer who had suffered some temporary form of insanity. Mr Rayer proceeded to try to stamp out the flames with his tin leg. Unfortunately they set fire to his trousers. I battered his leg with my clipboard and eventually darkness was restored. Mr Rayer, as was the norm, went on as if nothing had happened.

'Well, Philip, what do you think of the prices I'm putting on these things?'

We hadn't discussed any. That confirmed it, I thought. The pigeons had definitely left the coop. He had flipped. Trouble was, I didn't know how to proceed: I'd never worked with a madman before. I decided that honesty was the best course of action.

'I didn't think we had gone through any prices yet, Mr Rayer.'

'Philip, sometimes I think you don't concentrate. *Cumberland!*'

'I'm sorry, Mr Rayer, I don't understand,' I muttered.

'Lord help us, Philip! Didn't they teach you anything at Loughborough?'

Well, they did, but it was primarily kicking rugby balls, hitting cricket balls and throwing javelins. My blank stare confirmed to Mr Rayer that I hadn't got the first idea what he was talking about.

'Cumberland, Philip. Cumberland. It's a code!'

Well, he hadn't gone mad, but I still didn't have the first idea what he was talking about. Evidently I looked as clueless as I felt because he elaborated: 'C – one, U – two, M – three, B – four, E – five, R – six, L – seven, A – eight, N – nine, D – nought. So seventy-five pounds is LE.'

Dawn broke. At long last I knew what he was talking about. I understood the code, but why did it exist?

My boss must have read my thoughts: 'Always do your valuations in code, Philip. You never know who might be looking over your shoulder.'

I peered round the room. It was as dark as an unlit coal cellar, further fogged by smog from the Rayer pipe, and Betty Castell had departed this mortal coil. Unless I was missing something we were on our own in the middle of nowhere. Mr Rayer sensed my bewilderment. 'Practise,

Philip, practise. Get used to it and you'll always use it. I can count in Cumberland.'

Now, I could see a real benefit in using it during a drinking game at the bar, but at the time it didn't strike me as essential to an auctioneer and valuer. (Years later, however, I confess I have my own code that, sadly, I can count in. I do not wish to disclose how it works, but it most definitely isn't Cumberland.)

We finally completed our valuation and set off back to the office. The gate-opening routine took the same pain-ful amount of time as before; this time I didn't offer to help and remained in the passenger seat, feeling guilty as I watched him struggle. This time the wire snagged his already singed trousers and I couldn't help but wonder what everyone would think of the state of his 'funeral suit'.

We arrived back at the office and I retreated to my top-floor sanctuary to try to make head or tail of the MADs, LADs and EMUs I had scribbled down during the day. I was due to meet Jim in the Greyhound after work for a quick pint, and the thought of a social activity reminded me of the invitation I had left in my car, which I still hadn't opened. I went down to the car park and pulled out the envelope: it was an invitation from the cricket club, which I had, unwittingly, let down, to attend a gala evening for players and spectators the following month. The club was in the Black Country where they took their cricket seriously and it was bound to be a special evening.

I checked in my diary and discovered I was free on the evening in question; this was hardly surprising since nothing else was written on any other page. I then re-read the invitation and saw what I regarded as a major problem: 'Mr Philip Serrell and Partner.' The nearest thing I had to a partner was Jim. I didn't see how I could go on my own as I really would look like Norman No Mates, and while Jim was a good friend I felt female company would be preferable. But who? This was a problem to discuss with Jim at the Greyhound. A black-tie do (it didn't say so on the tickets but it was bound to be), and I was in the social equivalent of solitary confinement.

Due to our continuing lack of funds Jim and I were at our slow-drinking best and were about a third of the way through our first pint, which had taken us nearly half an hour, when I decided to raise the topic of the gala evening.

'You could always take Alice who works in the shop by your office,' Jim suggested. I conjured up a mental picture of Alice. Now, I know I'm no oil painting, or the catch of the day, but Alice was like Quasimodo in need of a shave. I didn't need to say anything because Jim came up with another suggestion. 'What about that girl who works in the shoe shop? You know, the one with glasses and the braces on her teeth.' I think he'd answered his own question.

'Or what about the belter in our office? Ask Albert.'

'Ask Albert' sounded like a quiz programme.

'She's a bit out of my league and, besides, what about Richard Bridges? I thought she was going out with him. And if she's not, I thought you were next in line?'

'Not really. She sees me as a good friend and doesn't want to spoil that – you know it's the kiss of death when a bird says that – and RB hasn't been into the office for a while now so I don't think there's much going on there.'

I mulled it over and concluded reluctantly that there was more chance of me rowing to the moon than persuading a girl like Albert to go out with me, however grand the occasion. But before I could say so, Jim piped up, 'I'll ask her for you, if you like, if it would help?'

Jim wasn't known for tact: a subtle question from him was like being struck on the head with a mallet. Anything would be better than him 'helping' me. If I was going to ask her I would do it myself – and I told him so. And it really was an 'if'. If she turned me down, I didn't want Jim gloating that at least he had had a date with her. How, when and where I might ask her was something to think about carefully, as the conditions were going to have to be spot on for her to even consider my invitation.

Our pints had now lasted about an hour and a half; funds were so low that we couldn't even consider a top-up. That was another crucial factor in asking anybody to

the gala. There was bound to be a free bar and food laid on for the players, which, given my financial circumstances, meant that at least I could give whoever I took a good evening out. But would that be enough to tempt Albert?

Chapter Eight

Confessions of an Auctioneer

It was about three o'clock in the morning on one of the coldest nights of the year and I should have been happily tucked up in bed.

Shortage of money can make a man desperate, and this was why I had let myself be talked into such a situation. Mr Rayer had been instructed to sell the contents of a derelict house for the executors of a deceased estate. Said contents were numerous antiques and valuable collectables. He had decided to hold a sale on the premises, but as the house was unsafe it would have to be conducted in a marquee (he said). We needed security there to make sure nothing got stolen: would I do it? He would pay me some extra cash, and it would be like a Scout camp – a bit of an adventure (he said). I should have remembered that life was never that simple with Mr Rayer. It was like dipping your hand into a bran tub: you never knew what you were going to pull out.

So there I was, lying on a camp bed in a brand new

sleeping-bag, wide awake. At twenty-three I hadn't been in the Scouts for some time and didn't have a sleeping-bag, which meant I had had to buy one. My purchase, out of necessity, was the cheapest in the shop and made of rather flimsy nylon. It was not filled with goose down: gnat's hair was nearer the mark. I was frozen to the marrow but it was not only the sub-zero temperature that was keeping me awake. My teeth were chattering so loudly that the noise and vibrations from my mouth would have woken a corpse. I was in the marquee, as Mr Rayer called it, which was actually a large tent that belonged to the local hunt. As I lay there staring at the stars through its web-like roof I came to the conclusion that it had been designed by the same people who supply nets to Grimsby fish trawlers. The wind ripping through the side walls was positively Antarctic and I was sorely tempted to do a Titus Oates.

Mr Rayer, ever thoughtful, had ensured that I wasn't the only one on the team. To my left was Dai and to my right Windy Williams; both were sound asleep on ex-army camp beds covered with eiderdowns. Between them they sounded like the baritone section of a barbershop quartet. They had arrived the previous evening with some of Dai's scrumpy, which was of the most vicious variety; I had drunk about half a cup, which, to add to my discomfort, had given me severe heartburn. The huge stone jar of cider had been supplemented with strong mouldy cheese and pickled onions that went off in your

mouth like hand grenades. Dai and Windy had con-
sumed an amount that would have fed a small army with
suicide tendencies. Then they had decided it was time to
'further my education'. Dai had brought some playing
cards and a pegging board with him and they had kept
me up until midnight, by the light of a smoking oil lamp,
trying to teach me how to play crib. When they had
beaten me soundly, they had fallen asleep. Dai was
snoring with a vengeance and every time he exhaled,
the air turned white like hoar frost. Windy's supper had
clearly done nothing for his digestive peculiarities and he
continued to rumble away as loudly as he did when he
was upright. In the silence of the night it seemed even
louder. Between them they made an unbelievable noise. I
don't know how they managed it, but they were taking it
in turns to erupt. I tried turning my head from left to
right, defending each ear in turn against the cacophony,
but it didn't help.

Lying there, desperate for sleep, I started to think
about the cricket-club gala evening. I could see little
or no point in asking Albert: I've never been too strong
on rejection and that seemed the likely outcome. Perhaps
Jim was right and I should ask Alice: after all, she was
bound to say yes. No one ever asked Alice out. What
other options were there? None, was the short, sharp and
simple answer. My thoughts wandered on as the two
beside me enjoyed blissful slumber. I don't know why but
in the early hours of the morning when you can't sleep,

it's a rule that every time you consult your watch thinking an hour must have passed you discover it's only fifteen minutes since you last looked. Another rule is that every problem assumes gargantuan proportions. The question of who my partner would be for the gala evening was becoming all-consuming. I looked again at my watch; it was now six forty-five and I had had little or no sleep. Suddenly, and in the welcome way that it happens, I dropped off.

The next thing I knew, Dai was shouting, 'Come on, Phil, wake up!' as Windy shook me for all he was worth. The pair were breathing over me a mixture of last night's scrumpy and pickled onions; it was not pleasant. I looked at my watch: seven fifteen. I felt like death.

'Slept like a log. It's good to be outdoors and get some fresh air in your lungs. Reminds me of me army days,' Windy said.

Well, the air wasn't very fresh as far as I could smell. I thanked heaven I had been born too late for national service, if that was what they had had to endure.

'Bloody hell, Phil! You ain't much cop in the mornings, are you? We've got a lot to do today.'

I dragged myself out of my nylon bag and went to find somewhere to wash, shave and clean my teeth. The only facility was a bucket of ice-cold water; worse, Dai and Windy had got there before me. There seemed little or no point in moaning, though, particularly to those two: they

seemed positively to revel in hardship. I immersed myself in the second-hand icy water and got on with it.

The day started with the three of us bringing the contents of the house out to the tent and trying to sort out the various lots for sale. I was deemed, somewhat sarcastically but with good humour, to be the new Arthur Negus (the recognised TV antiques expert of the time) by my two helpers, and with my little knowledge tried to sort out what went where. The house was jammed solid with the good, the bad and the ugly: modest antiques next to rotting three-piece suites and old Burco boilers. To sort the wheat from the chaff, Dai had built a huge bonfire on to which all of the unsaleable rubbish was dumped. It always strikes me as strange how bonfires mesmerise men of a certain age: invariably they find a fork or a long stick to lean on or use, occasionally and lovingly, to prod the embers. Nothing much is said. Dai and Windy were of that certain age, which meant that most of the sorting and carrying was left to yours truly.

I trawled through the house and found that the antiques were (at least to my untrained eye) mostly commercial nineteenth-century furniture that the average antiques shop might stock. It was all in a fairly unloved condition; most needed, at best, renovation and, at worst, serious restoration. When I could drag the others away from the bonfire, the three of us got something of a system going. I pulled things out of the house and put

them by the front door. Dai took the rubbish to the bonfire and Windy carried the saleable items to the tent. The first floor of the property was hazardous, as I discovered to my cost when I put my foot through the failing timber floorboards and grazed my shin. There was little point in asking for help because my cries would have gone unheard.

As I began to make inroads I found a pair of chairs in one room that I thought were rather good. They looked very old – probably eighteenth century; if there was a set of six they would, I reckoned, be worth a tidy sum. I decided to search everywhere. I had started to clear the house from the top and when there were no more to be found upstairs I decided to continue on the ground floor. I brought the two from upstairs down with me and began the hunt. After about half an hour I had unearthed another three and had lined them up by the door for Dai and Windy to take to the tent. I was now almost frantic to find the magical sixth, which I thought would make a tremendous difference to the price the chairs might make in the sale. After another fruitless half-hour I realised that I was wasting my time. Somewhat crestfallen, I went back to hauling out the rest of the saleable stuff, and the rubbish for the bonfire.

I was filled with apprehension at the prospect of another night under canvas with Dai and Windy. I could see why sleep deprivation was such a powerful tool in interrogating prisoners: I would have admitted to any-

thing after one night with those two and there were another three to go before the sale day. Not only that: the small hours would undoubtedly reawaken the partner problem for the gala cricket evening.

I toiled on for about another hour until it was too dark to continue. It was getting cold again: I had goose-bumps on my arms the size of grapes. I wandered outside to find the two fire-watchers staring into the embers of a blaze that would have thawed a polar ice-cap. Their faces bore a warm, ruddy glow that I envied. I joined them to be confronted with a hamper that I assumed contained fresh provisions for the night. The pair told me that Mr Rayer, being the man he was, had not forgotten his troops in the battlefield and, while I was on my chair hunt, had dropped off some more bread and cheese for our supper. Thankfully, there was no more cider but he had brought two bottles of home-made rose-petal wine. This was altogether a better option than the cider and I looked forward to a glass or two that evening.

I joined the other two in staring at the fire. None of us said anything as we gazed into the flames and it was half an hour before I jolted myself back to reality – with some shame: I had been sucked into this old man's game. It was time to open the hamper. A freshly baked loaf, sweet pickle and cheese that merely removed the enamel from the teeth were an improvement on last night's fare. We uncorked the wine and Dai poured a generous quantity into each of the three tin mugs he had found; I didn't like

to enquire too closely into where exactly he had discovered them. I picked mine up and took a slug. I have never drunk aftershave or paraffin but that wine tasted like a mixture of the two. Nothing, either before or since, has burnt quite like that liquid did as I swallowed it. My throat was on fire and felt like the map on the opening titles to *Bonanza*.

'Drop o' good stuff this, Phil,' chortled Dai. I couldn't reply as I was still unable to breathe.

'Knock it down and we'll have another,' Windy said.

'No. I'm fine, thanks,' I whispered.

Neither tried to persuade me, reasoning, I supposed, that the less I had, the more there was for them. They were welcome to it. The long night followed the same pattern, except that crib was replaced with Farmers' Glory, another game they tried to teach me with a similar lack of success.

I was woken the next morning after about an hour's sleep more than I'd had the night before. That day and the next night followed the same routine, and pretty much everything that was saleable was out in the tent by lunchtime on Friday. It took place before the days of glossy catalogues: Mr Rayer's idea of PR and marketing was to place a long list in the local newspapers and a brief advert in the antiques trade paper. Come the sale on Saturday, all sorts of buyers would be in attendance, from the neighbouring farmers inquisitive to learn what mysteries the house had concealed to the specialist an-

tiques dealer scouring for hidden treasure that others had missed.

I was wandering around on the Friday afternoon making sure that all was in order and generally titivating when I remembered we hadn't burned all of the rubbish from a small pantry adjoining the kitchen. I thought I'd better drag some of it out for Dai and Windy to put on their bonfire, which had been going now for nearly four days. Half-way through the exercise I caught sight of a chair leg that looked like those on the five chairs I thought were so valuable. Excitedly I reached down to pull it out of its hiding place, and that was all it was, a leg. I picked up the piece of turned Georgian mahogany and placed it by the outside door of the kitchen. Then I delved further into the tangled mass on the floor and found another front leg. Eventually I had every remnant of the sixth chair, which was now in kit form, showing the ravages of time. I placed them all by the door, then thought I had better go and check on the other five in the tent just to make sure I hadn't got it completely wrong.

I can't deny that, as I wandered outside, I felt rather proud that I had found the missing link and ensured that a good set of period chairs had been salvaged. Although it was in pieces I was sure that the last one would add value to the other five. In fact, I was so proud of myself that I decided to share my news with Windy and Dai. I strode over to the bonfire where the pair were in their classic pose: one leaning on a stick, the other on a fork.

'You'll never guess what I've done,' I said. This brought no response: they continued to stare wistfully into the fire. I was about to ask the same question again when, despite the heat of the bonfire, I suddenly felt very cold. Something familiar was sticking out of the fire. It was my chair leg, and as I peered into the ashes I could make out the rest of my eighteenth-century-chair kit. I was horrified. 'Dai, is that the bits of a chair that I left by the kitchen door?'

'Yes, bloody old thing. Nobody's going to buy a chair in that state. Can't understand why folk keep rubbish like that around them.'

My heart sank to my kneecaps. I didn't know what to do.

'You've gone white, Phil. Come and have a warm by the fire – it's going nicely now.'

Indeed it was. With my chair. There was no point in telling them what they had done. The question was, should I tell Mr Rayer? Lord knows what he would say. I decided that, for the moment, discretion was the better part of valour and that I would keep quiet. Perhaps I would pluck up courage and tell him on the sale day. Strangely, I felt almost as if it was my fault.

It meant I had a completely sleepless last night. Apart from the noise Dai and Windy were emanating and my concern over my date for the gala do, I now had the destruction of a really good set of chairs on my conscience. The other two had sunk into a peaceful coma,

induced by two bottles of Victoria plum wine that I hadn't bothered to taste – it had smelt dreadful. I reckon I managed about three twenty-minute naps before dawn broke.

I wandered into the tent and stared at the five chairs. I wondered if, now that we were in the Common Market, going decimal and metric, perhaps it wouldn't matter about the sixth chair. They could be a metric half-set, five from a set of ten.

At about eight thirty Mr Rayer arrived, at the same time as the early birds among those wishing to view the sale.

'You all right, Philip? You look like you've found sixpence and lost a shilling.' If only he knew.

As the sale time came closer the place heaved with people and, to my consternation, the serious antiques dealers I knew made a beeline for the chairs. I kept meaning to say something to Mr Rayer but never found the opportune moment before the sale started. Perhaps, more truthfully, the moment arose and my courage failed me.

Everything seemed to be selling well, with most of the boxes of sundry china we had put together going for between ten and thirty pounds. One old oil painting with a rip in it raised £330 and a battered long-case clock fetched a good price, in a keen contest between two local farmers, at £680. I was surprised that most of the dealers were still hanging around; they were obviously waiting for something.

The chairs were one of the last lots. Finally Mr Rayer got to them. 'There you are, then. Bid me for these five good Georgian mahogany dining chairs – pity there aren't six.' That last remark was like a knife wound.

'Hundred pounds somewhere?'

A forest of hands shot up and, in no time at all, we had reached a thousand. I felt awful. The bid was now between two determined buyers: one was the best of the local dealers, and the other was someone I didn't recognise. On the bidding went – fifteen hundred, two thousand . . . I was growing colder by the minute. Finally I heard Mr Rayer say, 'Sold to you, sir, two thousand eight hundred and fifty pounds.'

The successful bidder was the man I didn't know. I walked up to the local dealer and asked who the buyer was.

'Top London furniture dealer. God knows how he'd heard about the sale and those chairs.'

Then I heard myself ask the sixty-four-thousand-dollar question – and trembled. 'Would a sixth have made a lot of difference?'

'Not much!' he replied, with just a hint of sarcasm. 'Probably would have doubled the value.'

Never hit a man when he's down. Kick him – it's easier. I was mortified. Perhaps it would be better if I told Mr Rayer on the Monday morning after the sale when we were safely back in the office. It would be a bit easier then, I convinced myself.

I was supposed to be meeting Jim in the Greyhound that night; we always met after a sale to discuss how things had gone at the auction. I couldn't face him: I felt physically sick about the chairs – and also from the battering my stomach had endured over the last four days. I was shattered from what had been about four hours' sleep during my nights under canvas, and I couldn't face the third degree about who I was going to take to the cricket club do. I went home and slept for almost the entire weekend before I would confront Mr Rayer and my conscience at work on Monday morning.

Well, Monday came, and I'm ashamed to say I couldn't bring myself to tell him. I didn't see what he could do about it and it remained my secret. Until now, that is.

Chapter Nine

Painted Fruit

I was still struggling to come to terms with the secret of the burned chair as I wandered up Foregate Street to get a paper before I left for the saleroom in Malvern. I wandered past Lloyd and Gold and spied the wondrous Albert pinning up fresh details of properties for sale in their display window. Dream on, I thought. As I stared into the window Jim's grinning features appeared. To my horror, he pointed at Albert and gave a huge thumbs-up. I felt myself go bright red and had started to make protesting gestures at Jim when Albert looked up and saw me apparently doing an impression of a beetroot directing planes on to an aircraft carrier. I stuck my head down and walked on to the paper shop. There was Alice. I got a beautiful smile as I asked for a paper and a packet of twenty Peter Stuyvesant cigarettes. Trouble was, the smile revealed a row of teeth that a thirty-year-old sheep would have been embarrassed by. I felt ashamed to have made such a cross judgement on someone who was

obviously such a lovely character, particularly when I
caught sight of myself in the mirror. I picked up my paper
and smokes and shot out of the door.

I meandered back to the office where Mr Rayer was
engaged, so I went over to the saleroom in Malvern. Mr
Rayer travelled round the county with his nomadic tribe
of Dai, Windy and me conducting a variety of on-the-
premises sales, but it was in Malvern, on the eastern
slopes of the hills, that in-house auctions were conducted.

I busied myself with setting up the next sale, which was
to take place in ten days' time. Things looked a bit thin, I
thought. The firm specialised in selling wares produced
by the local Royal Worcester porcelain factory and it was
an area that one day I wanted to make a speciality of my
own – I'd given up on silver. The factory had always held
a special place in my heart; I can still remember walking
around its museum as a youngster on a school outing and
being captivated by the contents, which, dated back to
the company's formation in 1751. Such was its pull that I
would go there during school holidays and always played
the same game: I would wander round the cabinets,
gazing at the contents, then deciding which piece I would,
if I could, take home with me. My choice varied but I
usually came back to a pair of fabulous nineteenth-
century mugs decorated with hunting scenes. It was
not that I was particularly interested in hunting but
the scenes were full of the colour of the countryside in
which I lived. The whole place was an inspiration to me

then and still is now when I'm lucky enough to go back there. (I would recommend anyone to visit and be amazed by it.)

I was thinking about how I could drum up more business when a gentleman walked into the saleroom. It is always the way with auctions: panic sets in when a sale looms and lots are scarce, then something comes in off the streets. He was about fifty-five and fairly nondescript; although he did seem to have what I called wandering-eye syndrome. As we talked, he never looked me in the face but his eyes darted all around the room.

'I'm looking to sell some Worcester Porcelain and wondered if I could talk to someone who deals with it,' he said.

I decided to take the bull by the horns and become that person. Take the initiative, I thought, be assertive and get the items in for sale. 'Bring them in, sir, and I'll have a look at them for you.'

I could see him thinking that perhaps I was a bit young to be a pot expert but he turned on his heel and came back into the saleroom with a huge box that he was struggling to carry. 'There's another to bring in yet,' he puffed.

I was beginning to get cold feet: suppose it was a rare collection from the early years of the factory that I knew little about? When he staggered back in, I started to unpack the box on one of the saleroom trestle tables. I was breaking into a minor cold sweat and my hands were

almost shaking as I opened the flaps of the lid and saw the regulation old newspaper wrapped round the contents. I don't know why I had said what I had; my lack of knowledge was surely about to reveal me as a fraud. I would be in real trouble if Mr Rayer found out; for him professional integrity was everything.

'It's a collection of Painted Fruit,' my new client advised.

Thank the Lord for that, I thought. His words were like an oxygen tank to a drowning man. Painted Fruit was the term used for wares produced by the Worcester factory from the 1930s to the present day. It was a hand-painted design of peaches, apples, pears, cherries and blackcurrants that covered the whole of a piece and was painted by a number of hugely talented artists, both then and now. The real joy was that each plate had a date code on the back that was relatively easy to decipher and was signed on the front by the artist who had painted it. Not only that, we had sold a number of Painted Fruit items in the saleroom recently so all my comparables for valuation were at hand. The confidence I had shown initially was returning and I was relishing the task ahead.

We unpacked the boxes together and the tables were soon looking like the front window of an old-fashioned fruit and veg shop, laden with produce on those green-plastic imitation grass mats they used to have. There were lots of bowls, plates and dishes all signed by the same artist. I took the opportunity to pick up one plate

and saw a black back stamp. This was the factory mark: in the 1930s it had been pink or puce, but around 1960 it had been changed to black without a date code for each year.

I started to go through the pieces, putting estimates on each item of between a hundred and three hundred pounds. Now my client was showing confidence in me: 'You seem to know quite a bit about this lot, especially for such a young man.' I was trying to work out whether that was a compliment or an insult when he continued, 'I'll leave the reserves up to you.'

Perhaps he *was* impressed by my knowledge. Anyway, it was time to prepare the paperwork. 'Your name, sir?'

'Brown, John Brown,' came the response.

'Address, sir?'

'Twenty-three, Harmer Avenue, West Acton, London.'

'You've come a long way, sir.'

'Yes,' he replied. 'You need to travel if you want the best advice.'

I could feel my chest swelling with self-importance. I knew the firm had a good reputation for selling Worcester Porcelain and now I was part of that reputation. I itemised all of the pieces and tallied the total of the reserve prices. Nearly four thousand pounds. I was so pleased with myself that I decided to telephone Mr Rayer in the Worcester office and tell him of the coup I had pulled off.

'Well done, Philip. I'll leave you to deal with this on your own. You seem to have done a good job so far. Best get an advert ready for the local papers.'

I had the client's confidence and now my boss's. Things were looking rosy on all fronts. I managed to find an old white sheet in the rear of the saleroom and used it as a background for a photograph of the Painted Fruit for the advert. I took a great deal of time over my display and reeled off several shots with the office camera, then whizzed down to the local chemist to get the film developed. Next I prepared an advert listing all of the collection. By the time I left for home I was feeling positively smug. It had been fascinating to go through the items piece by piece: each one was similar but subtly different from any of the pieces we had sold before. There were no ornamental vases, but the tableware was unusual and collectable.

I pulled into the Greyhound car park to see that Jim had beaten me to it: his car was parked at the front and I found him ensconced on a stool at the bar looking pleased with himself. Well, I was feeling pretty good too. Before I could tell him about my Worcester Porcelain he shouted, 'I reckon I've sorted it for you.'

'What?'

'The gala evening. I've sorted it for you.'

I was at something of a loss. 'What?' I repeated.

'Albert. I've laid the ground for you. I told her about the bash and the date and she's free. Reckon she'll come. All you've got to do is ask her.'

'Cheers, Jim,' I said, with some sarcasm. I suppose I should have been grateful, really – he thought he'd done me a favour – but I felt a bit of a fool. 'All you've got to do is ask her' might seem simple, but it could still lead to a negative response from the lovely Albert. All Jim had done was leave me with no option but to ask her and risk humiliation. My report on the good collection of pots I had to sell didn't seem important now.

I was really enthusiastic about that collection of Royal Worcester Painted Fruit and gave a lot of thought as to how the firm should market it. I reckoned the best plan would be to run off prints of the photograph I had taken and send it to dealers and collectors whose names we had on file. I also thought it would be a good idea to have viewing on the afternoon before the sale as well as on the sale morning. Mr Rayer's attitude to all of this was interesting: he couldn't see the point as the firm had coped without these new-fangled ideas since 1791. I tried to suggest to him that we had moved away from coming to work on horseback and using quill pens, then remembered some of my boss's habits and thought perhaps we hadn't. Still, he was either indulging or encouraging his latest pupil, and it could do little harm.

Dai and Windy were supposed to be helping me in the saleroom as there were no outside sales to prepare. They made me very nervous around fine porcelain, particularly after the cremation of the sixth chair. Neither man had a feel for the fine arts: Dai was not noted for his

delicate touch and Windy was so accident-prone he could have broken a house brick with a feather duster. I spent most of my time watching them rather than doing anything constructive. Every time they walked past that collection of Worcester my heart was in my mouth. I was certain they would accidentally sabotage the sale. They made me so nervous that eventually I suggested they wander off to the bookmaker's just down the road: they both had a penchant for the gee-gees. They were delighted at my proposal and went off like two schoolboys who had just been given a half day.

I had made sure that all of the adverts were placed and the mailing registers up to date with details of potential buyers; it was going to be a good sale. The ground work was now complete and it was just a question of waiting for the day. Time to turn my attention to the cricket club gala evening. If I left the saleroom now I could get back to Worcester in time to pop up to Lloyd and Gold's office. There, I would put Jim, possibly Albert and myself out of our collective misery. I had made up my mind that now was the moment.

I parked my car at the rear of our Worcester office and walked into the main reception. Hinge and Bracket were there, each with a cigarette on the go, accompanied by Mr Rayer, who had a full bowl of camel dung in his pipe that he had just ignited. I was desperate to get out of the office before my courage failed – and also because I wasn't sure my lungs could take so much smog. I made a

feeble excuse about needing to see one of the many antiques dealers in the city who might be interested in the collection of Painted Fruit and shot out of the door.

It was only fifty yards to Jim's office but it seemed like miles. As I got closer the confidence seeped out of me. My pace slowed and it seemed an age before I got there. I was almost relieved when I arrived and there was no sign of Albert in the front office, just the two other receptionists and another trainee. More importantly, there was no sign of Jim. I toyed with the idea of going in and then, horror of horrors, Albert appeared with Jim following her. He saw me and gave Albert a nudge, which he followed up with a wink and a finger pointed in my direction for all in the office to see. I felt my face turn the colour of a tomato. Any remaining wisp of confidence evaporated. Then, to make matters worse, Jim started waving at me to come into the office. He was as subtle as a rubber cosh: his arms were rotating like the sails of a windmill in a force-nine gale. I had no option but to go in before he dislocated his shoulders. I felt like the condemned man as I walked through the door, except I hadn't eaten a hearty meal.

'I, er . . . I, er . . . I, er, wondered if you would, er . . .'

Albert was staring at me as if I was suffering from some form of dementia, Jim was trying to egg me on, like a prompter with a megaphone in a village hall panto-mime, and the two receptionists were staring at us wondering what on earth was going on.

'I, um . . . I, um, thought that if, um . . .' I spluttered on.

Jim's frustration got the better of him. 'For God's sake, man, ask her.'

'Well, I, er . . . um . . .'

'Bloody hell, will you go with him to a bash at his old cricket club in two weeks' time?'

It seemed quite easy when the words came out of someone else's mouth. I was wishing the ground would swallow me up but Albert answered almost instanta-neously: 'Yes, I'd love to.'

'Pardon?' I said.

'Thank God for that,' said Jim

'I'd love to, really,' said Albert.

'Oh, right,' I said. 'I'll let you know the details.' I bade them all good afternoon and floated back to the office.

'How did you get on, Philip?' Mr Rayer asked, through the fog, as I walked back into the office. How on earth did he know about Albert? I thought. 'Do you think they'll come and buy?' he continued.

What on earth was he talking about? Then I remem-bered the supposed reason for my trip up the high street. 'Yes, Mr Rayer, I think it should be all right.' I couldn't think of much else to say.

The response to my advertising had been positive. Several telephone callers had told me how unusual the collection was, and many of them had never seen ex-amples like the ones in the sale. Things were looking

good, and all I had to do was keep destructive Dai and wrecking Windy away from the fragile pots.

The viewing day arrived and was surprisingly quiet; I could only imagine that most people were either not used to viewing on the day before a sale or would come on the sale day to save a second trip to the saleroom. There was an exception. Two gentlemen appeared shortly after the viewing had opened. They both looked thoroughly businesslike although neither seemed much like a pot collector. One had on a grey suit, carried a clipboard and was making copious notes (which, I thought, must be a good sign) while the other was in black trousers, a blue quilted anorak-type jacket and thick-soled, highly polished black shoes. He wasn't saying anything, just standing behind the other man. Strangely, he didn't show any interest in the Painted Fruit. Well, I supposed it didn't matter too much; one interested party was better than none. They seemed to be taking an age, but if notes were anything to go by the first man would be bidding a fortune. They had taken about an hour in their deliberations when I decided to make myself a coffee. We had the slowest-boiling kettle in the world so it was an eternity before I returned, to find the two men waiting for me by the office door. They looked a bit stern but I supposed for them business was business and they wanted to leave me some bids.

Shiny Shoes stepped forward and opened his wallet. We hadn't got a catalogue to sell him so I wasn't sure

why he was getting money out. Then he extracted a card, which he put politely under my nose. The words 'Worcestershire Constabulary' grabbed my attention.

'I'm Sergeant Jenkins and this is Mr Wilde from the factory. Could we have a word?'

It was more of a statement than a question and didn't seem to require an answer. 'Words' with policemen, tax inspectors and lawyers were to be avoided at all costs, my granddad always said: they usually involved bad news and expense.

'Mr Serrell, could you tell us where that impressive-looking collection of Painted Fruit came from?'

'Um, er, a client from London walked in off the street with it one day not so long ago.'

'And does your company usually accept items for sale from people who just walk in off the street?'

I felt uneasy with Sergeant Jenkins's tone and decided to assert myself a little more strongly. 'Well, we are specialists in the sale of these wares and would expect to handle fine and rare pieces like these.'

Mr Wilde from the factory added his own damning observations. 'Fake, Mr Serrell, all fake!'

My prized collection of Royal Worcester Painted Fruit was counterfeit. Someone had got hold of a load of ordinary tableware and had painted it with the aforesaid fruit, signed it, fired it in a kiln and brought it to me to sell. I felt physically sick. Grey Suit went on, 'It really is pretty poor quality – an expert, or even someone with a

modicum of knowledge, would have spotted it straight away.'

I passed beyond nausea to numbness. The whole episode seemed surreal, particularly when Shiny Shoes issued me with a receipt and Grey Suit took the pots away with him. Exhibit A, m'lud, I thought.

I retreated to the Greyhound to find Jim full of himself for having set me up with Albert, but the humiliation of the afternoon had floored me. Not even the prospect of a night out with Albert could help. It was a salutary lesson, but a painful one.

Postscript: my collection of Worcester porcelain made the local papers, but not, as I had intended, with record-making prices. The court case made the headlines as Mr John Brown and his colleagues were given the opportunity of a holiday at Her Majesty's pleasure.

Chapter Ten

Big Mal's Car

I was mortified by the fake china episode, especially as it came so soon after the burned chair. My confidence was at an all-time low and even the cricket club gala evening was relegated to the back-burner as I thought of nothing but my two huge errors of judgement. It was quite a relief when Mr Rayer decided I should spend some time gaining further experience in other aspects of the business. He pointed out to me quietly that it was acceptable, though not desirable, to make a mistake but his patience and trust might be tested if I made the same one twice.

My new task was to go to Malvern to meet my fellow trainee in the firm's estate-agency office there and pick up some small items of office furniture and a few 'sundry effects', as Mr Rayer put it, from a building on an industrial estate at the far side of Ledbury.

The estate-agency office was situated on Malvern's steep Church Street. My fellow trainee was one Iain Hunter, the local doctor's son. He greeted me cheerily,

as ever: 'Well done you, mate. Heard you got a date with that Albert! Hey, and a pity about the china – bit of a cock-up. Could have happened to anybody.'

I didn't know what to say. News travelled fast: my potential love life was now in the public domain, all ready to turn round and bite me, while the fake china had become a skeleton in my cupboard. At least the chair was still between me and my conscience.

'H', as he was known to all, was an enthusiast in everything he did. He was an optimist in the extreme; his pint glass was perpetually half full rather than half empty. His enthusiasm extended to his car, which was a Morris Marina twin-cam model. It was his pride and joy and he purchased every available extra for it, from go-faster stripes to spotlights that a passing ship might have mistaken for a lighthouse beam. His *pièce de résistance*, however, was a set of snow chains that he had bought from one of the firm's farm sales in August. I tried to point out to him that his purchase might have been not only a little premature but overly hopeful, given that they appeared to have come off the rear wheels of a tractor. That was no deterrent to H.

'Just you wait till winter. With a little fettling they'll fit a treat. I'm really looking forward to some snow.'

When snow did fall in the county it always settled in Malvern first and any substantial falls rendered the roads around the hills impassable. H prayed for the white stuff to fall and the gods conspired against him. Poor old H, he

was almost distraught at having no opportunity to tack up the Marina with its metal chains that would enable him to boldly go where others feared to drive.

We were standing in the reception area of the Malvern office discussing how we would load Mr Rayer's 'office furniture and a few effects' into our two cars when it happened. I was standing with my back to the window when I realised that H was rather distracted.

'Look! Bloody *look*!' he cried. 'It's only bloody snowing!'

This remark prompted two reactions. The first, from me, was one of despair that the morning's appointment would be disrupted. The second came from Miss Small and Miss Holland, the two secretaries. The Malvern office had been opened in 1861 and we two trainees had always reckoned that those ladies had been there since the opening night. (Neither was that old but H and I felt anyone over forty was surely on the downhill slope.) They began to tut simultaneously, not at the snow, which was now falling in larger flakes, but from the use, *twice*, of a swear word. Misses Small and Holland didn't do swear words.

H could hardly contain his glee as he shot out to the Marina, which was parked outside the office. The boot was opened with a force that nearly took it off its rusting hinges and out came the chains. I had forgotten how much of them there was; they looked to me more like tank tracks than anything that could, or should, be fitted

to a product of the Longbridge factory. I poked my head out through the door. Snowflakes the size of soup plates were now settling. 'Are you sure about those things, H?' I asked.

'You just wait!' he cried, lying in the snow under the rear wheels of the Marina with a spanner that could have changed the wheel nuts on a juggernaut. 'We'd be able to get across the frozen wastes in this.'

Somehow I didn't share his confidence and decided to watch the rest of the snow-chain fitting from the comfort of the office. By now quite a crowd had gathered to witness H transform his humble Marina into a snowmobile. After about twenty-five minutes, and what seemed like twelve inches of snow had fallen, the task was complete.

'Come on, mate, let's give her a rip!'

Prophetic words. I declined H's offer, deciding, once more, that discretion was the better part of valour. I ventured outside but watched from the safety of the pavement.

H threw open the driver's door and leaped in, turning the ignition key before his behind had landed in the driver's seat. I had forgotten quite how much noise the car emitted. This was due to two of H's other little improvements: an exhaust pipe so big it could have housed a badger's sett, and a very loud stereo system from which Abba's *Greatest Hits* deafened those inside. Slowly but surely the Marina moved forward, gathering

pace as the chains whirred round on the rear tyres. They didn't seem to fit quite as tightly as they should. The crowd looked on with a mixture of curiosity and amusement. I must admit the old girl – the car, not an onlooker – was making good progress up the steep street, but there was an awful lot of noise . . . and sparks. Sparks? Surely there shouldn't be sparks. Everything became horribly clear. The chains were not as tight as they should have been. In fact, they were slacker than the elastic in a pair of worn out Y-fronts. Rather than turning within the wheel arches as they should have done, they were spinning at a ferocious rate. Metal and splinters flew off in all directions, like the chariot scene in *Ben Hur*. Undeterred, and possibly unable to hear through the noise of the exhaust and the stereo system, H gunned the accelerator. What was left of the rear wings was now ripped off. The crowd watched in amazement. Wisely, with the sixth sense that people develop when something is not quite right, H stopped.

'Bugger!' he said. There wasn't much else to say.

This was not going to help us in our task for Mr Rayer. The fates had conspired against me in everything I had touched of late. The rest of the morning was taken up with picking up the metal shards that glistened in the snow and were all that was left of the rear wings. Once this task was completed we thought it best to move the Marina away from the scene of the crime. Miraculously the tyres were still in one piece and the car was just about

driveable. The snow had now abated and Church Street was manageable with care.

H drove the car gingerly away. His parents lived about a mile and a half from the office and about twenty minutes later he was back, dropped off outside the door by his long-suffering mother. His enthusiasm had not waned. 'You know, mate, this could be an ideal opportunity. Now I've got to do the rear wings I may as well flare them to beef the old girl up a bit, and fit some chunkier tyres. She'll look like a real racer.'

I toyed with asking how much more money he intended to spend on a car that had cost him just three hundred pounds. Too late: he was already drawing designs on the back of an envelope for a machine that would not have looked out of place in a *Mad Max* film.

A minor problem was looming on the horizon. Weather permitting, H and I were supposed to be driving to Ledbury to collect the office furniture and effects that were to be included in the next auction. I reckoned there was enough to fill a car and a half and now all we had was the Mini.

'No problem. I'll have a word with Big Mal. He'll lend me his car.'

Malcolm George Henry Hodges was as meticulous about his car as he was about his appearance. The vehicle was always kept, like his Cary Grant suits, in immaculate condition. Woe betide anyone who threatened his natural order of things. Big Mal was currently driving a new

Volvo estate that was only about seven months old and, if anything, was in better condition now than when it had left Sweden. (By a strange quirk of fate Big Mal's son, Nigel, became Big Nige, my haulage man, in later years.) I thought H had more chance of plaiting fog than coming back with an affirmative to his request.

But he did it. H somehow persuaded Big Mal to loan us his car for our removal trip. H would be driving, yet I still felt responsible. I was not looking forward to our trip to the west of the hills.

As quickly as it had come, the snow cleared and we set off on our journey. We made our way to Ledbury with me leading. I thought I was driving quite fast but my rear-view mirror was constantly filled with Big Mal's shiny Volvo. It was not so shiny now, as H seemed to make straight for every bit of muck and rubbish on the roads, which stuck to it like the proverbial to a blanket. We eventually arrived at our destination: when I got out of the Mini, Big Mal's Volvo looked as if it had just competed in an autocross rally.

The offices from which we were to collect the furniture consisted of a brick-built, asbestos-roofed, single-storey block on a small trading estate. The first problem was to gain access. A burglar alarm was fitted to the unit but Mr Rayer had carefully written the code on a piece of paper for me to deactivate it. Why hadn't I checked it before we left? I knew what his written instructions were like. The pencil had struck again: his one looked like a seven, while

three could have been five. The four-digit code contained either ones or sevens and threes or fives.

'Bugger me, mate. He's your boss, you should know his handwriting,' was not the sort of constructive remark I was looking for from H. 'Just pump in what you think it is. I'm sure you'll get it right.'

With my recent track record for getting it right, I didn't share his confidence. I dithered.

'Give it here – I'll do it.' H grabbed the bit of paper and said, 'There you are, look – seven three five one,' and he pushed the appropriate buttons. It seemed to work: silence ensued, and we walked further into the unit.

'*Christ, that's loud!*' At least, I think that was what H yelled, but I could barely hear him over the deafening siren we had set off. '*Go and switch the bloody thing off!*' he shouted at me.

I thought it was a little unfair of him to delegate responsibility when he had messed up, but I obeyed, pushing buttons on the control pad like a man possessed. James Bond trying to deactivate a nuclear bomb couldn't have worked more feverishly. Trouble was, he always got it right in the nick of time and this damn thing was still making enough noise to wake the dead. I was almost more horrified to see H appear with a huge pair of bolt-cutters.

'*Cut it off the wall, mate. Cut off the power supply,*' was the latest suggestion from my partner in crime.

'*H, do you really think we should be doing this? We'll wreck the alarm.*'

'*Can't hear you, mate. Bloody alarm's loud, isn't it?*'

I repeated my protest to no avail: H cut the wires feeding the alarm system and pulled it off the wall. The only difference now was that I was holding a wailing alarm, rather than it being screwed to the wall.

'*Bloody hell! That thing's good. Wouldn't have thought it would work after that.*'

There was now a loud banging on the office door. Great, I thought. No doubt it was the police.

'*Leave it to me, mate, I'll sort it.*' Somehow H's words did not offer much comfort as he strode to the front door. I was left standing in the reception area, my imagination running riot as I tried to picture a police cell; presumably for a first offence we might get a suspended sentence – but if they thought I had been involved with the dodgy china . . .

'*No worries, mate. Bloke from next door says it's not wired to the police station and should . . .*'

Suddenly, miraculously, there was silence.

'. . . stop soon.'

We had wasted so much time I thought we should get on with loading the cars. There were a few chairs, a filing cabinet and about ten fire extinguishers that would need to go into the Volvo. Into the Mini I could get the two typewriters, filing trays, two fans and about a ton of paper that Mr Rayer was adamant we should take back with us. Ooby was stacked to the roof, which was now a lot closer to the ground than it had been earlier, owing to

sheer weight. It was time to load the Volvo. We dropped the rear seats and raised the board that was fitted immediately behind the front seats: designed by some fiendishly clever Swedish boffin, it was there to protect the fabric of the front seats in the event of the load moving during a journey. Knowing Big Mal, I would have been happier if we could have wrapped the whole lot in cotton wool. We had a long debate about where to put the fire extinguishers. Each was filled with whatever ghastly substance fire extinguishers contain – liquid foam? – and H reasoned that as they were the heaviest part of our load they should be put in first in a row along the width of the car against the board. We gingerly placed them in the car with the nozzles at the front, conscious that any undue pressure would set them off. Having installed the dangerous part of our cargo, we put in the chairs and the filing cabinet, then piled some files on top, carefully avoiding anything that might tear the roof lining. I had underestimated how much we had to take back to the saleroom, but with care, precision and a certain amount of language that Misses Small and Holland would have disapproved of, we eventually fitted it all in.

'Look, H, you take it really steady. Big Mal will have our guts for garters if you so much as drive through another muddy puddle. You know how proud he is of his new baby.'

I set off up the road and was pleased that H was taking

me at my word. I could see from the rear-view mirror that he was dropping behind. Still, that wasn't a problem as he knew the road back to the saleroom. At that time, he was going out with a girl from a nearby village and would have driven the route in the Marina many a time. We passed over some common land with sheep grazing at the road's edge. I cruised round a sweeping right-hand bend and suddenly realised I had left H behind. I thought I had better slow down: he was driving really carefully. Fifty miles an hour, forty, thirty, twenty. Where the hell was he? Eventually I pulled over to wait for him. I was glad he was taking his responsibility seriously and motoring at a steady pace. But there was still no sign of him – surely I hadn't been going that fast. I was growing a little anxious and, after what seemed an eternity, decided to turn round and see where he was. I hoped he was driving at a snail's pace and would suddenly appear. On I drove, across the common, round the big bend and – there was H. The pristine new Volvo was at a standstill, straddling the dotted white line, with the tailgate open. H was at the back hurling across the road files, chairs, more files, filing-cabinet drawers and more files.

The snow had gone yet there seemed to be a white covering over absolutely everything. I pulled on to the common and ran to Big Mal's car. The white stuff was getting denser and, bizarrely, floating up towards the sky, not the other way round. As I got closer H, flinging files like a man possessed, shouted, *'Bloody sheep!*

Bloody old ewe ran out in front of me. I was so paranoid after the lecture you gave me I threw out the anchors and the sodding fire extinguishers shot forward. The bloody plungers hit that board and set them off!'

I was laughing so much that tears ran down my face. The Volvo now resembled a clown's vehicle at the circus. But my hilarity died when I remembered whose car it was. It was now nearly empty – but for white foam everywhere. Drying my eyes I suggested tentatively that the middle of the road was not the best place to park.

'Sod off!' H's response was a little harsh, I thought. 'If I'd driven at my normal pace I'd have missed the bloody animal!'

My main concern was not the office effects but the state of Big Mal's interior. H pulled the car over, and was still cursing as I pushed him into the back through the tailgate to defoam it. We scooped out the offending substance using two old file covers from our load. When we'd finished we looked like two of Mr Blobby's victims.

Amazingly the interior was unscathed; if anything it was even cleaner than usual after its foam bath. We reloaded the car and were about to drive on to the saleroom when H, who seemed a little flustered, suggested a plan. 'Look, mate, what Big Mal doesn't know won't hurt him. Just don't mention the alarm episode or the problem with the sheep. Keep shtum.'

I agreed.

We eventually got back to the Malvern office, having

unloaded the cars at the saleroom, to find that Big Mal and Ten o'Clock Ted were in a meeting in the senior partners' office. We decided to sit in the reception area and wait for them to come out of the inner sanctum. H was showing me his plans for the alterations to Marina when we were interrupted by two police officers.

'Good afternoon. Wonder if you can help us? We're trying to trace the owner of a new Volvo estate car involved in a robbery. We believe it belongs to a Mr Malcolm Hodges who works here. Could we have a word with him, please?'

The colour drained from our faces and beads of sweat appeared on our brows. Strangely, at the same time, we lost the power of speech. Miss Small insisted on showing them to his office. I looked at H and he looked at me. There didn't seem much point in saying anything. After what seemed an eternity, Big Mal appeared. He didn't look very happy.

'You two, in here, now.' Heads bowed, we followed him into his office. 'These two officers think my car was involved in a robbery earlier this afternoon. Apparently the thieves were spotted throwing part of their haul across the common between here and Ledbury. Perhaps you could enlighten us as to what you've been up to this afternoon.'

So much for 'What Big Mal doesn't know won't hurt him'. H unveiled the whole sorry saga. Mr Rayer didn't say anything during the whole interview but I swear I

saw him chuckle more than once. Eventually H had persuaded the police that we weren't Malvern's answer to the Great Train Robbers. The worst part was the look of hurt that appeared on Big Mal's face when he heard how his new car had been abused. As we made our way to the reception area my accomplice whispered, 'Bloody hell, mate, that was a close call. Let me know how you get on with Albert.'

For all that effort and heartache the contents of the two cars made just over sixty-five pounds. Not the most profitable trip I'd undertaken for Bentley, Hobbs and Mytton. Was it really worthwhile? Mr Rayer's view was, unsurprisingly, that the fee was irrelevant, though I'm not sure what damage H and I had done to our reputation with Big Mal.

Chapter Eleven

A Magical Evening

'For God's sake, you've got the date! You have to speak to her and tell her where you're going and what she's got to wear.' Wise words from Jim Johnson over another slow pint in the Greyhound.

It was all well and good Jim giving me the benefit of his experience in matters of the heart and my evening out with Albert. I hadn't noticed him having much success when *he* took out the object of our desire. I was terrified of mucking the whole night up. While it had seemed like a good idea to ask her out, on reflection I was wishing I had taken the softer option of asking Alice. It's better sometimes to travel in expectation than to arrive in disappointment.

'She's asked me if you're going to pop in and give her a bit more info. The do's this Friday and you can't leave it till the eleventh hour.'

I supposed Jim was right. I had consciously avoided the offices of Lloyd and Gold and hadn't clapped eyes on

Albert in days. I couldn't put it off any longer. 'Look, I'll pop up to your office in the morning and definitely sort it.' That shut him up on the Albert front, only for another thorny issue to arise.

'It's got to be your shout. We've broken our own record for slow drinking tonight.' He thrust an empty pint glass at me. Grudgingly I walked up to the bar and spent the last few bob I had in my pocket.

I was up early the next morning and emptied the dregs of the Hai Karate bottle over my tingling face after the morning's shave. In the advert the application of this particular aftershave had the wearer fighting off a gorgeous dusky Amazon of a young lady. To date it had not produced the same results for me; I stared at the empty bottle. Hobson's choice dictated that the last remnants in my only other bottle of aftershave, Brut 69, would have to be saved for Friday night. Henry Cooper, eat your heart out. I drove off to work and decided to go straight to Lloyd and Gold's offices. Jim, bless him, knowing that an appearance from me was imminent could not keep out of the reception area. As soon as he saw me he started jigging about, waving his arms with a huge smile on his face. Albert was nowhere to be seen. I walked in and at that moment Albert appeared through one of the rear doors in the office.

'Bloody hell, what's that smell?'

Thanks, Jim. That was all I needed to bolster my flagging confidence. Worse was to follow.

'It's like something the cat's done. Is it your after-shave?'

Albert smiled in a charitable manner that spoke volumes.

'It's not that bad – strong, but not that bad.' Suitably chastened, I thought it best to get the point of the visit out of the way and turned to Albert. Jim was standing about two feet from us, which was hardly calculated to make me feel comfortable.

'Alb – Alb –' I struggled to remember her name – I only ever thought of her as Albert. 'Alb – About Friday night,' I stammered. 'Shall I pick you up at seven thirty? The do starts about eight thirty and it's forty-five minutes' drive.'

'That's fine,' smiled Albert. 'What should I wear?'

'Well, it's a gala evening so I'm going to wear a DJ. I'm sure you'll look great in whatever you've got. It should be quite a posh do.' I could see myself now – DJ, little red Mini and Brut aftershave. Not quite James Bond but, hopefully, a passable imitation.

'Great. Pick me up from home. It's Keane House on the Kidderminster road out of Droitwich.'

And that was that. All sorted. Perhaps Jim was right: I'd been making mountains out of molehills and it would all turn out fine. The sky suddenly became a bit bluer, my life was obviously set for a change and things were on the up. I was beginning to look forward to Friday night's gala evening.

The rest of the week seemed to take a month to pass

but at long last Friday arrived. I was in the office bright and early, trying to keep my head down for fear of a Mr Rayer appointment. All went smoothly during the day and I managed to keep well out of his way. I was relaxing in the middle of the afternoon, sitting in the front office talking to Hinge and Bracket, so I didn't hear Mr Rayer coming down the stairs. I must have been miles away, daydreaming about my night out, because his footsteps were akin to a series of howitzers firing one after the other. I was doomed.

He came through the door. 'Ah, Philip, been looking for you all day. You must have been busy – look forward to hearing what you've been doing while we're in the car.'

'Sorry, Mr Rayer,' I stammered.

'No need to be sorry. As I said, you've obviously been busy. You can tell me about your day on the way to Burton Hall. We've got to go and see the Slaters to discuss planning potential on some of their outbuildings.'

I was doomed: a visit to the Slaters was never quick. Hinge, bless her, knew of my date and piped up, 'Mr Rayer, Philip has to be back here at six for another appointment.'

'We'll easily be back by then.'

Some hope. I was like a condemned man walking to the gallows as we made our way to Thunderbird IV in the car park.

The journey to Burton Hall was relatively uneventful –

or perhaps my state of mind was such that near misses didn't register. I noticed only one minor bit of offroading as Mr Rayer lit his pipe but it was the least of my worries. The countryside on the way to Burton Hall was glorious, with open views towards the Welsh Marches. The hall was the stately home of the Slater family, although home was something of an understatement – it was more like an aircraft hangar.

We arrived at about four o'clock to be met by Mrs Slater. Certain niceties had to be observed: Colonel Slater was out, seeing one of the tenants on the estate, and she told us he would be back shortly. My chin sank to my bootstraps. There was no way I'd be able to pick up Albert on time and the night was destined to be the disaster I had always feared.

Colonel Slater appeared after what had felt like eternity; in reality it was about fifteen minutes. The whole meeting went by in a haze. Five o'clock came and went, then five thirty. Before I knew it, it was six. I didn't mind the night with Albert being a disaster, but I would have liked to mess it up for myself without Mr Rayer's help. I sat in the library staring at the wall.

'Good Lord, Philip, look at the time! We've got to get you back to Worcester for your appointment.' Mr Rayer got up and walked to the door. It was unheard of for him to be so positive. Perhaps there was a God after all. We clambered into the old Triumph and drove back to Worcester. We were making quite fair time until we

came up behind a lady in a Morris 1000 Traveller, who was driving at a sedate twenty-nine miles an hour. Mr Rayer decided to tailgate her and, to my amazement, did not pass her on a mile-long straight but waited until we were going round a blind corner. Then he indicated, pulled out and overtook her on the apex of the bend to a cry of 'Out of the way, madam, we're in a rush!'

I was numb with fear, but when I opened my eyes it dawned on me that if I lived long enough I might make it on time after all. We got back to the office and I flew home in my little Mini. I had just enough time to throw on my DJ and splash on the last of the Brut aftershave. I drove the three miles to Albert's house and pulled up in the gravelled driveway. The doorway had a chain that rang a bell you could hear in the depths of the house. I waited for the door to be opened, congratulating myself on being punctual after all. I don't know why I was expecting Albert to appear, but she didn't: the door was answered by a striking-looking lady in her mid-fifties. This was obviously her mother: the similarity was amazing. They always say that if you're thinking of marrying someone look at her mother first because that's what you'll end up with.

'Do come in. You must be Philip. Rosemary shouldn't be long.' I was ushered into the drawing room and asked to sit down. In a corner I saw a pair of grey flannel trousers, legs crossed, with no upper body. From the waist up all that was visible was a fully opened copy of

The Times. There was no movement from behind the newspaper, no acknowledgement of my presence, just a screen of newsprint. I could sense that someone was wearing the trousers but it might easily have been the bottom half of a tailor's dummy.

'Dear, Philip has come to collect Rosemary.'

At that the newspaper dropped an inch or two for a split second, just long enough for me to catch a glimpse of Albert's father. He was about six feet tall with receding grey hair and didn't look too happy. As the paper dipped, I heard a noise that was a cross between a growl and a grunt; I think it may have been 'Hello' but I couldn't be sure. 'Mrs Albert' (as I nicknamed her) showed me to a seat and I tried to direct some sort of conversation towards the newspaper.

'Trust you've had a good day?' I thought was polite enough. No response. There was nothing like being made to feel at home and this was nothing like being made to feel at home. I felt sick. Albert's dad obviously didn't see the cheap-aftershave-smelling trainee as catch of the day for his daughter. After waiting for what seemed, yet again, eternity, but was in fact ten minutes, Albert appeared.

She looked stunning in a long blue cocktail dress with a white feather boa. Her perfume was evidently at the opposite end of the expense spectrum from my choice. She had a real air of sophistication and I was proud to think she was my date. I had little doubt that we would stand out from the crowd at the cricket club.

' ''Bye, Daddy' was met by the same dip of the newspaper and a grunt, but this time I was sure there was a hint of a smile, albeit directed at Albert rather than at her escort for the evening. We walked out into the hall where Mrs Albert held the door open, smiled and said, 'Have a lovely evening, darling. You both look fabulous.'

Confidence restored, head high, I walked Albert to Ooby and the dodgy passenger door, which still stuck a little from Mr Rayer's abuse. After a little struggle I managed to open it and Albert slid gracefully into the seat. I was conscious that it didn't compare to Richard Bridges' sports car but the atmosphere seemed good and I was looking forward to the evening.

The journey to the cricket club passed in no time. Albert knew nothing about cricket, she said, but seemed interested in my playing career and was amused by my tale of how it had come to an end. She was easy company, and as we got closer to our destination the conversation turned to what sort of night we could expect.

'I think it will be quite a high-profile do,' I said. 'It's the club's big event of the year and all of the players will be there. Probably a large number of fans and spectators too.'

I hadn't been to one of these galas before but I had assumed there would be a proper sitdown meal with an awards presentation and speeches at the end.

We pulled into the car park at the same time as a

rusting white Transit van, whose side proudly pro-
claimed 'Black Country Felt Roofing' in shaky writing.
I didn't recognise it as the transport of one of the players:
it must belong to a supporter. I parked the car and got
out quickly, partly because I wanted to act the gentleman
and open the door for Albert, but also because I was
concerned that if I left it to her she would struggle to open
the misshapen door. She got out gracefully.

I thought we looked a million dollars. We walked
round the back of the Transit as the driver and his female
companion got out. He was wearing a Wolves football
shirt, faded jeans, with what looked like the remains of a
roofing job staining the right leg, and a pair of trainers.
She was in jeans too, with a T-shirt that bore the logo 'Go
to the Black Country to get felt'. I could see that Albert
was a bit anxious. She wasn't the only one.

'They're probably part of the catering or bar staff,' I
suggested nervously.

'Yowm the booger that dow tern oop, ain't yow?'
Clearly he had the advantage in that he recognised me. I
didn't know who he was, and I was struggling to under-
stand the broad Black Country dialect.

'Gonnerbe a bostin' night, ay it? Yow cor beat fagits
'n' pays, can yow? Am yow tow the tern?'

I didn't want to appear rude to the staff but I had no
idea what he was talking about. I could only assume that
'fagits 'n' pays' was roofing terminology. I smiled, took
Albert's arm, and we made our way to the clubhouse. My

mouth was a bit dry. The invite hadn't said DJs and no one had told me that that was the dress code, but as it was the club's night of the year I couldn't imagine it would be anything else.

'They're really lovely people, salt of the earth, but the local lingo takes a bit of getting used to,' I whispered to Albert. I smiled as I compared the accent to the clipped, cut-crystal tones of the Slaters whom I had been with earlier in the day. We entered the empty clubhouse foyer to be greeted by a huge poster; my heart sank. It announced the club's forthcoming 'Home Made Faggots and Peas Night'. So that was what the roofer had been talking about. I was wondering how to explain this to Albert but I needn't have worried: she had clearly seen the sign too.

'I've never eaten faggots,' she remarked.

Oh, Lord, this had all the hallmarks of a disaster.

Albert sensed my anxiety and tried to put me at ease: 'Don't worry, I'm sure it will be fun. Different, but fun.'

I had got the tone of the evening wrong. This was confirmed when we walked into the main clubhouse. It was packed, and everyone was dressed like our new friends from the Black Country Felt Roofing Company. I quickly looked round the sea of faces, searching for someone I recognised. A man strode purposefully up to us. 'Oo booked yow, then? I dow now nothing 'bout a'nact.'

I was beginning to grasp the accent: we were thought

to be the evening's cabaret. I was shaking with nerves and my tongue was so dry now you could have struck matches on it. I glanced nervously at Albert. Bless her, she was trying to suppress a giggle and gave my arm a comforting squeeze. I could have hugged her.

'Ar, we normerly 'as a tern but yowm news to me, baber. Still see'n' as ow yowm 'ere now, am yow singers or one o they magical terns?'

It was time to lighten his darkness. 'Actually, I played cricket in the early part of the season and we're here for the function.'

'Yow ay that orkshunayer wore let us darn, am yow?' Ah, my reputation. 'Day yow think yowm a bit over-dressed – dow yow?'

A positive response to both questions seemed unnecessary. Albert and I began to mingle a little, experiencing the same dry Black Country humour from one and all. I was mortified but Albert was a star – in every sense of the word: she looked like a Miss World entrant at a welders' convention.

'Just don't worry,' she murmured. 'We'll still have a good time. They're really friendly people and faggots will be a new experience. I'm just going to pop into the cloakroom.'

I watched as she walked across the room and all eyes followed her; I felt so proud that she was with me. At that moment I felt a tap on the shoulder and turned to see one of my former playing colleagues. 'Don't you think you're

a mite overdressed?' He followed up his highly original comment with 'Heard you were coming. On past record didn't expect to see you till it was nearly all over. Tell you what, though, she's a belter. If she's half as nice as she looks you've struck gold there.'

I explained that it was our first date and so far it had not gone quite as I had planned. Then Albert was walking back to me, wearing a beaming, and disarming, smile. She stopped to chat to a number of the supporters on her way across the room. It dawned on me that they were keener to speak to her than to me. At last she returned. 'Apparently the faggots are to be served soon. They're made by a local lady who keeps her recipe secret. The locals tell me they're really spicy and an acquired taste.'

I wasn't sure whether this was a good thing or not, but I had no time to discuss the contents of the local delicacy with her as a man appeared on the stage at the far end of the club, ringing a bell. 'Ar bet yow cor wait any longar. The fagits am cooked 'n' the pays am mushed. Yowm in for a real treat, ar can tell yow. Form a quow, form a quow.'

Albert was entering into the spirit of things and dragged me by the arm to our place near the front of the queue. There were two huge dishes on a trestle table; one contained a mountain of grapefruit-sized brown things covered with a strange sauce while in the other lay a mound of grey-green stodge. I wasn't

looking forward to this: the smell of the faggots was unbelievable and not pleasant. I quietly voiced my concern to Albert, who assured me that I really should sample the local delicacy. We took our plates to a table and prepared to test our tastebuds. The smell was overpowering now and my stomach was turning somersaults. I wasn't sure I could go through with this. Albert took a mouthful of the meat hand grenade and I watched her face contort. 'I'm not really sure about these, after all, but when in Rome!'

The girl had pluck by the bucketful, far more than I did. I proceeded to push the faggot round my plate and, I'm ashamed to say, to drop increasingly bigger bits on to the floor under the table. Finally our plates were empty. Albert had eaten hers and seemed to be turning green. She became increasingly monosyllabic, and conversation was non-existent. Clearly she had realised that she had dated a complete idiot who had taken her out on one of the worst nights of her life. She then confirmed this: 'I think I'd like to go now.'

Well, that was the end of a beautiful relationship. We said nothing as we walked to the car. Even the wretched passenger door was conspiring against me. It refused to open. 'I really would like to go – now,' she repeated, quite firmly. The friendly smile had disappeared. But the door wouldn't budge so, to compound my embarrassment, I had to ask her to climb in through the driver's door. I got in and started the car. We drove back towards

Worcestershire in silence. We had gone about twenty miles when Albert suddenly spoke again: 'Is there any way you could go a little faster, please? I think I'm going to be—'

At that her face contorted and turned a more vivid green. I had thought she had been ignoring me but she wasn't feeling well. Then the faggots and peas made a spectacular re-entrance into the world. Her beautiful blue dress looked as if it had been pebbledashed with wet grey-green-brown mortar and the map pocket in the door of my Mini was filled with it.

'I'm so—' I think she was going to say 'sorry', but before she could, we had a repeat performance. I was mortified. I had got her dressed up like a dog's dinner to go to a do, only to poison her. Utter silence, growing more oppressive by the mile, reigned for the rest of the journey, although we did have another four explosions. Eventually I pulled into her driveway. Albert didn't bother to try to open the passenger door but climbed over the driver's seat as soon as I had got out. Holding her hand over her mouth, she shot in through the front door without a word.

I stood there looking at the door as it closed. I'd wanted to say how sorry I was but she was rather preoccupied. So my initial fears had been confirmed: I hadn't been sure what kind of disaster would befall the evening but, sure enough, a disaster it had been.

A Magical Evening

I walked back to my car, opened the door and climbed in. I drove home with my head hanging out of the window, gulping fresh air. I was feeling a little queasy myself but whether that was due to the state of my car or the catastrophic events of the evening I couldn't say.

Chapter Twelve

~~

'Ride him, cowboy!'

What could I do after such a fiasco except get my head down and concentrate on work? I avoided the offices of Lloyd and Gold, while interrogation from Jim in the Greyhound as to what had happened met with noncommittal answers, but he would not let it go.

'I don't know what the hell you did but Albert keeps saying she doesn't want to talk about it.' That was pretty much my view of the evening. There was, however, a constant reminder for me every time I jumped into my Mini. It was getting colder by the day and the one thing that really worked well on Ooby was the heater. At times, it operated like a blast furnace. However, the lingering aroma in the map pocket and the footwell was stronger with the application of heat. It became so overpowering that I seized every opportunity to go on trips with Mr Rayer in Thunderbird IV.

I was still the junior trainee in the firm and, as much as I wanted to spend more time in the saleroom, I had to do

as I was told by my boss. The firm ran the livestock markets in Worcester and Bromyard, and I still had my apprenticeship to serve on market days. Regrettably, this meant spending more time getting a lot closer to ill-tempered animals than I considered was either safe or advisable.

'Philip, we've got a horse and pony sale coming up at Bromyard market and I think it would be good experience for you to get involved.' Experience no doubt it would be, but *good*? I was wary of cattle, and after all my experiences with sheep I even found wearing a wool sweater traumatic. Horses, however, were in a different league. In short, they terrified me. As a child of about ten my parents had bought me a pony that went by the name of Smoky. Now, I'm sure in the right hands he would have been a sweet-natured little thing, but mine turned out not to be those hands. My opinion of horses was somewhat tainted by the actions of a family friend who came to visit one day. He was an expert horseman who was keen to inspect my steed. My parents were country people and had bought me all the right kit, and I certainly looked the part. But I was more interested in ball games than riding and had viewed Smoky with suspicion since the day he arrived. The family friend decided to help me on to the harmless little pony so that I could put Smoky through his paces. I was apprehensive about this, not looking forward to being put through *my* paces.

'Here we go, young man. We'll soon have you at the

Horse of the Year Show,' he said, as he grabbed me round the waist and lifted me into the saddle. I was about to point out that I was facing the wrong way when the family friend, who had a reputation as a practical joker, emitted a belly laugh and slapped Smoky's rump.

I've always admired the bareback riders at the circus who charge round the ring performing somersaults and other tricks to the delight of the crowd. Indeed, the pantomime that ensued bore certain similarities to their act. The wretched animal took off round the field with me clinging to its tail for all I was worth. I was bouncing up and down like a loosely filled sack of coal on a trampoline. My little brown velvet riding hat slipped over the front of my head, the reinforced peak catching me on the bridge of my nose, which made my eyes water to such an extent that, even if my view hadn't been obstructed by the hat I wouldn't have been able to see anything for tears. Of course, as a brave ten-year-old I would have had no other reason to cry.

'Ride him, cowboy!' roared the family friend, as the little pony hurtled round the field. Now, country folk who ride regularly will appreciate that you rise up and down in the saddle to the rhythm of a horse's stride; the trouble was that I was going up when I should have been going down and vice versa. My nose was sore and my behind was becoming equally tender. Smoky's sole goal seemed to be to shake off the irritant on his back. He can't have been more than four foot high and incapable

of moving much quicker than at a human's brisk walking speed. This was not how I saw it: I felt as if I was in the Grand National approaching Becher's – facing the wrong way. In common with Smoky, there was nothing I wanted more than to get off, but I wanted to achieve it in an orderly manner. Dignity went out of the window, though, as the wretched pony stopped, bucked and threw me off. My dismount was not too dissimilar to the action of a gymnast who flies off the high bar, except that I landed on my bottom rather than my feet.

With yet another unhappy memory to dwell on, I was well on my way with Mr Rayer to the market at Bromyard when I noticed a smell that, while it was different from Ooby's, was not pleasant. Mr Rayer was attempting to light his pipe and the car was filling with smoke. Along with the thickening haze and the pungent smell I had already identified, I couldn't ignore the additional odour of burning cloth. I glanced across at Mr Rayer's leg and saw a smouldering clump of tobacco burning through his trousers. He was unaware of it – he could not, of course, feel the heat from the pipe embers on his tin leg. Soon there would be another scorched hole on his thigh. While the smoke cleared the stench remained. Time to voice my concerns.

'Mr Rayer, can you smell something?' Given that his car didn't smell like the Boots perfume counter at the best of times I wasn't sure what response to expect.

'Pardon, Philip?'

'There seems to be a funny smell, Mr Rayer.'

'That'll be the pheasants.'

'Pardon, Mr Rayer?'

'Pheasants, Philip, pheasants.' Mr Rayer, as I was only too painfully aware, was sometimes oblivious to what was going on around him, but on this occasion he seemed to know I was lost, so he decided helpfully to expand on the theme. 'The missus doesn't like pheasant and I do.'

What had that to do with the smell in the car?

My confusion was stretching the patience of my employer. 'For the Lord's sake, Philip! I like to eat pheasant and my wife doesn't. After they've been shot but before you cook them, pheasants need to be hung and she won't have them in the house.'

I turned round and, sure enough, a brace of pheasant was hanging from the coat hook over the rear door. I peered closer. 'Mr Rayer . . . they're green . . . and there's maggots!'

'Good. Should be ready soon. Hang 'em by string and when the body drops away from the head you know they're ready.'

Ready for chucking in the bin, I thought, feeling decidedly ill. I hoped I was never invited to the Rayer household to eat pheasant.

Soon we arrived at the market in Bromyard. It was like going back in time. The office was a timber shed with gas lamps, an old wooden counter, at which the farmers paid their bills, and posters on the walls relating to various

animal ailments such as warble fly, whatever that was, and other unmentionables. Our task was to make sure that all was ready for the sale next week. We inspected the horse pens to ensure that they were sound, and put up trestle tables under one of the lean-tos where tack would be sold. Then we went to the sale ring. It was like a small auditorium with tiered wooden benches round a central circular ring where the livestock would be shown before they went under the hammer. On the far side of the circle there was a small wooden hut: the auctioneer's box. The structure was not dissimilar to Shakespeare's Globe Theatre. Everything seemed in order and we returned to the market office.

'Philip, it will be your job to put the lot numbers on the horses and to lead any round the ring that the owners don't want to take themselves.' It was a statement rather than a question so there seemed little point in trying to present a reasoned argument as to why I shouldn't perform either task; fear didn't seem much of an excuse. I was rather nervous at the thought of being in such close proximity to my equine friends but convinced myself that, provided I was careful, I couldn't come to any serious harm. Always beware the sucker punch when you drop your guard. We reached the office and he went on, 'You can mix up some of the glue and get the numbers we use for the cattle on market day.'

The glue was a horrible goo that had to be boiled up with water; I shuddered to think what its constituent

parts were. The numbers were another issue. In most sales I had been to with my father the lots on offer started at one and continued consecutively till the last in the sale. Not so with a Mr Rayer sale. He insisted on using up the last of the round three-inch-diameter paper labels left over from previous sales. He didn't believe in waste: his view was that a lot number was a method of identification and, providing no two lots carried the same number, all should be quite straightforward. Not many sales, other than Mr Rayer sales, started at lot thirty-eight, went on to lot forty-seven, fifty-three, fifty-four, sixty-seven and so on.

The week leading up to the sale passed without event, other than that I took a half-mile detour to walk up the main street in Worcester rather than going past Albert's office. It wasn't just Albert I was avoiding: despite Jim's constant calls I couldn't bring myself to put up with the third-degree at the Greyhound, and pleaded a complete lack of finance. Jim could not see this as a valid reason since it was a permanent rather than temporary state. None the less I refused to join him.

On the day of the horse sale I was at Bromyard bright and early boiling up the gluepot. I had concocted a cunning plan to avoid getting too close to the rear end of the sale entrants. I had found at home a long piece of plastic roof sheeting, cut it into pieces of about ten inches long and three inches wide. My plan was to give each vendor in the sale one of these plastic sticks with a

blob of glue on the end and their appropriate lot number so that they could stick it on to their animal, thus allowing me to keep well away from it. This worked well until one particular client came into the office. He was about five feet three, wore a long brown smock coat and ex-army boots with gaiters round the legs tied with baler twine. His face was ruddy and lined like the contours on a map, and he wore a flat cap perched at a ninety-degree angle on his head. He looked as if he hadn't shaved for about four days and an untipped cigarette was glued to his lower lip. Two inches of it was unsmoked, and there were two inches of ash, which didn't fall off. It looked like one of those cigarettes that can be bought from a joke shop.

'Ayr, laddie, yoos the one ay sees to buck in mae pornies.' The cigarette was still stuck to his bottom lip and the ash on the end trembled but didn't fall. 'Ay've mae pornies tuby bucked in. Breng em down frum Shetlan' mesen.'

The horrible truth dawned. Ponies, this time of the Scottish variety, had returned to haunt me. 'How many of them are there? I've got sticks for the glue and the lot numbers here.'

'Aye, a lorraful, all tuby sold with nae reserve. Ay'll nee' sum 'elp wi' the numbas.'

Worse, it appeared that I was expected to stick lot numbers on their rumps.

'How many are there, sir?'

'I dinnae ken. Kem off the moor nobbut twelve hour ago. Meby twentaye.'

Who on earth was going to buy twenty Shetland ponies?

My mind was clearly being read. 'Aye, thay'll mek it to the block. Thay'll be steak in France by the noon to-morrer.'

While I wasn't fond of Shetland ponies I thought it was sad that they could all end up in some abattoir, sold for meat. My guilt was made all the greater when they gazed at me with soulful eyes. The more I considered them the sorrier they looked, like a row of innocent men con-demned to the firing squad, knowing there would be no last-minute reprieve.

'Ow's yon numbers wurk? There's nae like this back hame.'

I hadn't the heart to tell him that no one else did it like this down here either. 'Oh, don't worry, they're only for identification,' I muttered. I had to go back to the office before my conscience got the better of me and I formed an escape committee for my shaggy friends from across the border. I walked into the office to hear three people talking agitatedly.

'I'm not sticking the number on the bloody thing. You can do it.'

'I should cocoa, do I look stupid?' another chipped in.

'Well, you can count me out. Get the lad to do it. Ssh – here he is.'

As I joined the happy band, the first one said, 'Wondered if you could lot up our horse for us?' I tried to think of a way out.

'Well . . . er . . . it's normal practice for the vendors to lot up their horses,' I said.

'We were told the trainee would lot him up and lead him round the sale ring.'

It was three against one. There seemed no way out. My demeanour closely resembled that of the doomed Shetland ponies as we walked to the pen where their horse was held. It was huge, at least ten feet tall, it seemed, but the worrying feature was its eyes: they were wild and staring and bulged out of their sockets. It was tied by a halter to the rail of the pen and seemed poised to clear the six-foot fence at the first opportunity. It was my worst nightmare. There were more hushed whispers from the group of owners.

'It must have been an accident. Mind you, he looks a bit wild. Don't tell the lad.'

Don't tell the lad what? It wasn't my immediate concern, though: I was more anxious with how I was to get a lot number on the rear end of the horse from hell without entering its pen.

'I'll be back in a minute.' I whimpered, and went back towards the market office, trying to buy myself time and work out what to do. There, I took inspiration from the office broom. I seized it and lashed one of my plastic sticks to the end of the handle with baler twine and

smeared a blob of glue on to it. I picked up a lot number at random, then strode back to the horse pen, quite pleased with my inventiveness.

I wasn't so pleased with it when I arrived. The horse was rearing and bucking for all it was worth. At any minute it would buckle the metal rail to which it was tied. The men were still murmuring furtively to one another. '. . . the ambulance had got there earlier the groom might have . . . Ssh, here's the lad.'

Ambulance? I didn't like the sound of that – and what might the groom have done? Without further hesitation I stuck the lot number on to the glue blob and planted the broom handle on the rear end of the bucking bronco. Luckily the number stuck, albeit upside-down, but the horse took exception to the indignity and went wild. I hoped it couldn't break free of its halter but I had no intention of stopping to find out if it would. I strode off towards the relative safety of the Shetland ponies, which now seemed tremendously appealing. As I marched over to the far side of the market where they were, I could see a circle of women gathered round the unshaven Scot. They didn't look like the usual market types; in fact, they looked more like 'ladies who lunch'. I made my way to the group.

'It's an absolute disgrace! These poor creatures! God's creatures are going to be murdered for the table,' shrieked the group's spokeswoman. There must have been about fifteen of them. The wee Scot seemed uninterested in the

ladies' protests and his indifference inflamed their right-eous anger.

I thought it best to try to smooth things down a little. My tentative 'Can I help, ladies?' was answered with 'Do you work here, young man?'

I nodded nervously.

'We are an action group, here to save these beautiful little ponies from the dinner table. We have seen your advert for the sale and, having read about the dreadful trade in horseflesh, we are here to do something about it.'

I looked to the Scot for support.

'Bloody do-gooding jessies. They dinnae understan' the wey o' things.' Hardly oil on troubled water.

I was starting to flounder when Mr Rayer made his way over to the commotion. I explained the problem to him, he lit his pipe, pondered for the time it took the smoke to disappear and gave Solomon's judgement. 'Best thing is, ladies, why don't you buy them yourselves?'

I was taken aback. The cunning old fox had solved the problem and ensured a sale at the same time. He strode off to the auction ring – the sale should have started ten minutes ago. I followed in his wake leaving the ladies chattering about who would buy which pony.

'I think we're all ready, Philip. The owners are happy to lead their lots round except the grey. They've asked you to do that. Be careful.'

Be careful. The words struck home like a dagger. For him to say I needed to be careful something must be

wrong. I made my way to where the grey was tied. There was quite a crowd looking at him, and a lot of animated talking and gesticulation, which seemed to stop with my arrival. At least it wasn't rearing as it had been before. I had no option but to do as I was told by my boss, and I certainly didn't want to lose face in front of the crowd. I decided to grab the bull by the horns, or the horse by the halter, and lead him to the sale ring. At once the muttering began again, and some snatches were worryingly audible: 'Well, he's got guts . . .'; 'He's a braver man than me . . .'; 'Where's the nearest hospital?' and such like.

Be firm and look straight ahead, I said to myself. The crowd parted like the Red Sea in front of me as I strode forward leading the grey, now behaving rather tamely, into the ring. Strangely, they all seemed awestruck. For the first and only time in my life, I had let an animal know who was boss, and it seemed to be working. My new-found bravery gave me fresh confidence. Then it happened. The horse seemed to take exception to the large crowd and decided to make a bolt for it. It was all reminiscent of Smoky, except this time I wasn't hanging on to a small pony but being dragged round the ring by a monster. Initially I managed to run behind it, holding the halter, but as the legs of the horse gathered speed, mine didn't. Over I went. I was now being dragged round the sawdust-strewn ring at breakneck pace. Two things occurred to me as we hurtled round the small perimeter:

first, that no one stepped forward to help me and, second, that Mr Rayer, bless him, was still taking bids for the grey. After several laps and four hundred guineas bid my not insubstantial weight must have tired it out and we came to a halt.

It was time to rediscover my new assertive self. I struggled back to my feet and marched the horse back to its pen as though nothing had happened. I tied it up and walked out, shutting the hurdle behind me. Then my knees turned to jelly and I went back to the office for a much needed brew of tea. There wasn't a huge number of horses and ponies or much tack to be sold, and even at Mr Rayer's pace the sale was concluded fairly quickly. He came into the office. 'You did well with that grey stallion, Philip, especially to hang on like you did. It could have been nasty.'

It *had* been nasty, but I was delighted with my boss's praise – he wasn't normally so effusive. I could feel my chest puffing out a little.

'The incident with its groom was unfortunate. The lad must have done something silly.'

Yet again I hadn't the first idea what he was talking about.

'Didn't I tell you, Philip?'

'Tell me what, Mr Rayer?'

There was an interminable pause as he lit his pipe. 'Well, that grey you led into the ring kicked his groom's head and killed him. Very unfortunate.' 'Unfortunate' wasn't the word I would have used.

Then it occurred to me to wonder: had he really forgotten to tell me – he was certainly capable of it – or had it been a memory lapse of convenience? There was no way I would ever know. We got into the Triumph and pulled out of the market to drive back to Worcester, but not before we had seen the ladies' branch of the Shetland Pony Freedom Fighters gathered protectively round their purchases. Between them they had bought all of the ponies for between eleven and seventeen pounds each, but it was clear that none of them had considered what they would do with them or how they would get them home. Mr Rayer looked at them, chuckled and got out his pipe. It was time for a smoke.

Chapter Thirteen

A Very Smelly Man

I was pleased to be back in the relatively friendly environs of the saleroom in Malvern. It was getting close to Christmas and there were no outside sales on the horizon until the New Year so Mr Rayer had decreed that together with Dickie Wilton, who normally worked in the company's livestock markets, Windy should be on hand to assist me. Frost was deep in the ground and the saleroom, with its thick local-stone walls, was as cold as charity. It was fine in the summer, but in winter it was one of those buildings from which you popped outside for a warm. It had a high, vaulted roof and an inadequate number of electric heaters hung on long pieces of flex from the ceiling beams. This meant that any heat they produced rose immediately to the rafters and ensured that all of the local birds perched on the ridge tiles, the warmest part of the building. The view from outside was not dissimilar to a scene from Hitchcock's *The Birds*.

Dickie and Windy were great company but of no real

use to me. Their knowledge of antiques was even sketchier than mine and neither was looking for a career path in the business. Dickie would wander around in his smock coat with a clipboard under his arm. Every now and then he would stop, pause, take down the pencil that was always placed at a forty-five-degree angle behind his left ear, and make notes on his pad. To the untrained eye he looked busy and I was intrigued as to what his copious jottings were about.

I found out when, on a rare occasion, he left his clipboard unattended in the office: it was his sales and purchase ledger for the produce he sold from his smallholding and contained details of who owed him what and when he would see them to collect his dues. Windy was always two paces behind doing his carthorse-on-a-diet-of-beans impression. Everyone who worked with him was well aware of his affliction and took it in their stride. In the cattle market even the farmers were aware of Windy's little problem and took no notice. He had been part of the furniture for years. The one person it never worried was Windy; I'm not even sure he was aware it was happening. However, as he spent little time in the saleroom I was concerned about what some of our more genteel clients might think when they heard him perform for the first time.

I had an appointment to see a gentleman who lived in Malvern. He wanted someone to look at the contents of his house, some of which he was considering selling. He

seemed quite well spoken on the telephone, if not a little confused.

'Good morning, is that the accountants?' was his opening gambit.

'No, sir,' I replied. 'I think you must have the wrong number.'

'Well, it's the number in the phone book. I want to sell some furniture and other bits.'

I started to backtrack. 'My mistake, sir. Sorry. Yes, you have got the right number, we are the *auctioneers*.'

'That's what I asked, are you the accountants? Can I make an appointment for you to come and see me?'

There seemed little point in prolonging the conversation so I arranged to go later that morning.

I was at the far end of the saleroom sorting out a box of uninspiring silver plate, with Dickie and Windy between me and the front door, when a well-dressed lady appeared. I thought I recognised her. She was not one of our saleroom regulars. It was Albert's mother. I was still avoiding Albert – and Jim for that matter: I had figured it was very much a case of out of sight out of mind for all parties concerned. I was sure I wasn't flavour of the month in the Albert household and was immediately concerned why Mrs Albert was paying us a visit to the saleroom, unless it was to issue me with a severe reprimand for trying to poison her daughter.

The saleroom was about forty yards long with Mrs Albert at one end, me at the other, and Dickie and Windy

midway between us. Panic set in as I saw Windy turn towards her. While it was not my problem, Windy was an embarrassment and I knew I had to get to her before he did. I set off at a swift walk at the same time as he started in her direction. We eyeballed each other and our paces grew longer and quicker as we raced to get to Mrs Albert first. I don't know what Windy had been eating but today seemed worse than normal: each pace was accompanied by a loud parping noise. It sounded as if someone had started a two-stroke lawnmower that was running a little rich, and in the cavernous space of the saleroom, with its high ceiling, the noise developed a booming echo so that the source was indistinguishable. I could see Mrs Albert looking at me. Convinced she thought I was the culprit, I began to run. Windy and I reached her simultaneously; his exertions had clearly had a dire effect on his whole system as he was now popping and rumbling when stationary, which was hitherto un-heard of.

'Good to see you, Mrs, Al, er, Hall,' I quickly corrected myself. I was about to enquire into the state of her daughter's health when Windy, in a body-shaking con-vulsion, cleared his throat – as it were. At least now Mrs Albert was in no doubt as to the origin of the noise. I looked at Windy. 'I think you can leave us now. I'll deal with Mrs Hall.' The poor woman watched helplessly as Windy wandered back towards Dickie and the clipboard. 'Can I help you?'

'Well, Rosemary told me that you sell a lot of Worcester Porcelain and I have a vase I would like your advice on.' I was so relieved: not only had she not come to issue a severe rollicking but she respected my opinion. My spirits rose: if I could do a good job my standing might rise from the all-time-low position it currently held in the Hall household.

'I would be delighted to look at it,' I offered, trying to sound professional rather than sickly-syrupy. She unwrapped the vase. It had certainly been made at the local factory, I guessed in about 1900, but it was not a world beater. It was of a peach colour known as blushed ivory and was decorated with hand-painted flowers. It was a bit boring and worth, I thought, between sixty and ninety pounds. Its main attribute was that it was in perfect condition.

'I was hoping it might make a hundred and fifty pounds.'

If I'd had more experience I'd have told her immediately that her view was a little optimistic, but I didn't. It's always better to be honest with an appraisal and nip false optimism in the bud than let an item be offered at auction with the vendor having unrealistic expectations. I winced as I heard myself say, 'Yes, I think it could do that, we'll put a reserve on it for you of that amount.' And then I asked the question I had been longing to since she walked into the saleroom 'And how is, er . . . Rosemary?'

'She's well, thank you. Thank you for dealing with the

vase for me. I'll look forward to it selling and receiving your cheque.'

I gave her the receipt and couldn't help wondering if I'd dug a hole for myself as she went out. But it was time to meet the man who thought I was an accountant so I pushed the thought aside.

It was one of those dark winter days that stays dull. A lot of the houses in Malvern are constructed from the local granite and the address he had given me was an avenue of semi-detached houses that had been built just after the turn of the last century. All had been tastefully modernised with bright lights shining through expensive curtains . . . all except one. The local stone was perhaps a bit grey and drab, and this house personified that look. Outside, it appeared that the timber below the guttering, the window frames and the front door had not been painted since the Edwardian builder had installed them all those years ago. The lights were also on in this house but they could not have been accused of brightness: the bulbs could only have been about fifteen watts. I knocked on the flaking front door, which had once been a rich shade of Sherwood Green, and my client answered.

'Are you the accountant?'

It was a grey day, I was at a grey house and, my Lord, he was a grey man. I thought he was about sixty-five but might have been ten years out either way. He had grey hair that looked as if it had been washed last on his tenth birthday. It wasn't the sophisticated white grey of Big

Mal but a dull steel colour and with a serious outbreak of dandruff. His face was the same unhealthy hue as his hair and had not been shaved for a week or so; when he spoke, his mouth revealed a row of rotting brown stumps that at one time would have been teeth. He stood about six feet three and was so thin he might have been the victim of a wartime concentration camp. A strange smell hung about him of stale lard that had been fried, fried and refried. I felt a bit queasy.

The house was in serious need of total restoration: none of the décor had been touched for years but instead of quaint period charm the air of decay was everywhere. It was also absolutely jam-packed with good things – and I had only got as far as the front door. I thought it advisable not to get into a discussion of the difference between an auctioneer and an accountant.

'I'm the man you telephoned earlier to come and look at the things you may wish to sell.'

'Excellent!' he said. 'The house is full of old things and I want to sell some of them to get a bit of space.'

We made our way into the hall and he was right: the house was full to bursting. Its other remarkable feature was that it was lit by gas. I was staggered that in this day and age someone could live without electricity. Somehow it seemed acceptable in the market office at Bromyard but not in someone's home. On a table in the hall a tin-plate model of a 1930s racing car, about three feet long, caught my eye. It wasn't a toy, but would have lit up

the eyes of any boy, young or old, at Christmas, and it was something that I, as a car nut, would have given my eye-teeth for. I picked it up and decided to dive in at the deep end. 'Have you any idea what this might be worth, sir?' I ventured.

'Well,' he replied, 'Mother bought it for me as a birthday present when I was a boy. I've no idea, really, but I suppose it could make as much as fifty pounds.'

This was my cue to surprise him with my knowledge and his good fortune. 'Sir, I think this could make between eight and twelve hundred pounds in the sale-room.' I stood back and waited for a reaction. Nothing – not a flicker of surprise or delight. I was a bit nonplussed and thought I'd better ask what specifically he wanted to sell.

'Anything of any value, really. That's the point of having you here. I don't know if any of this stuff is worth anything.' As the front door closed behind us and we wandered into the sitting room it became apparent that the house had another overpowering odour: ammonia. The room was a mess with piles of old clothes and newspaper spread across the floor. The odd patches of carpet that were visible were horribly stained, as were the chair and sofa. I was starting to gag.

'Do sit down. I'm sorry, I didn't get your name?'

'It's Philip Serrell, sir,' I said. I was about to sit down on the cloth-covered sofa when some of Mr Rayer's early words of advice came back to me in the nick of time. He

had told me that many of our older clients had 'a weak bladder', as he put it. This was certainly the case with my strange new client. Mr Rayer had told me never to sit down in such a house unless it was on one of those rexine-covered chairs that fluid would run off. Anything that was upholstered in foam would soak up any liquid until the next unsuspecting soul sat on it when it would release its contents like a squeezed sponge. My behind was about three inches from the cushion when I shot upright, pleading a serious back injury that made it impossible to sit down for any length of time. The stench was so appalling I had to get out a handkerchief and hold it over my nose. 'I've got one of those dreadful colds coming that starts with a tickly nose.' Feeble, I know, but it was all I could think of. I felt like the Lone Ranger as I muffled on, 'You've got some really interesting things.'

I had to get on with the job and get out of there as quickly as possible. We wandered through the house and I found it was the same story everywhere. Everything I picked up he thought was worth a tenth of its true value. The whole house was like the front room: a filthy public toilet with clothes and papers spread everywhere.

It was time to focus the conversation before I was sick on the spot. 'Would you like to sell any of the items we've talked about?'

'Well, yes indeed,' he answered, 'but your prices seem rather high. Are you sure they're right?'

I was absolutely positive but I couldn't stand being

there any longer. 'Look, I'll go back to the saleroom and give you a call tomorrow to see what you think but I'm sure we can achieve the figures I've quoted you.' With that I left, and drove back to the saleroom, gasping in fresh air. The thing about bad smells is that they tend to linger in the nostrils long after they've gone. I was convinced the gents' urinal smell had permeated my clothes. Lord knows what anyone I bumped into might think, other than that I had developed some serious bladder problem of my own.

I pulled up outside the saleroom and walked in. Dickie and Windy were not backward in airing their views. 'Jesus, where the 'ell 'ave you been? Fell in a septic tank?'

Rather than explain, I decided to ignore the pair. 'Make sure you keep that vase safe that Mrs Hall brought in.'

'Don't worry,' said Windy. 'It's on the shelves at the back.'

The next day I telephoned the 'Smelly House'. This time I thought it best to play things reasonably simply. 'It's Philip Serrell from the er . . . accountants. I was ringing to see if you wanted to sell any of the items I looked at yesterday?'

'Well, yes, but I'm still unsure about your values.'

This was a new one on me: most clients got upset when my valuations didn't meet their expectations, not when they exceeded them tenfold.

'After you had gone I had a gentleman knock on the door who bought antiques, said he was from out of the area and on a buying trip. I have to say, Mr Serrell, he thought my guesses were nearer the mark than yours. He said he would call back tomorrow.'

Now, there are good dealers and bad ones, just as there are good auctioneers and bad ones. A 'knocker' in my opinion, is at the bottom end of the bad-dealer list, a man who cold calls on likely houses, saying he's on a buying trip in the area and prepared to offer cash for any items that may be for sale. One of their tricks is to offer an over-the-top sum for a large piece of furniture, and when the home owner says he's happy to sell at that price the knocker announces that he cannot take it today but will call back tomorrow to pay for it and pick it up. Having gained the confidence of the home owner he then offers a pittance for something worth a tidy sum. The vendor assumes that because such a good price was offered for the large piece the second price must be fair too. The knocker pays the sum agreed for the second piece and, of course, is never seen again. This is *not* a practice that any *bona fide* antiques dealer would adopt: he or she is happy to give a formal receipt with a name and address on it, particularly if the address is that of a known shop.

'I really think you should be careful. I'm confident that we can achieve the prices I quoted.' I was worried for a potential client who, I felt, was a little vulnerable. 'Give me a call tomorrow and let me know what you want to

do, but I honestly think it would be best to use the saleroom.'

At that he put the phone down.

I spent the rest of the day busying myself in the saleroom. I was quite concerned about the 'smelly man'. While I appreciated that he might not want to use the saleroom and that a reputable dealer might match the prices I had quoted I didn't want to see him ripped off by a conman. Mr Smelly Man was clearly not the full ticket but who would ensure he was not taken advantage of? No one.

The next day the telephone rang. It was him again.

'Mr Serrell, I've sold the model car you liked to the gentleman who called the other day. He really was quite adamant that it was worth no more than the fifty pounds I'd thought and that was what he paid me.' My heart sinking, I asked what else he had sold. 'Nothing,' he said. 'I've decided not to get rid of any more at the moment. The man I sold the car to seemed quite upset that I wouldn't.'

I bet he was, I thought. This was soul-destroying on two counts; first, that Mr Smelly Man had clearly been cheated and, second, that I had missed out on some good things to sell in the saleroom. But there was nothing I could do. You win some, you lose some. Time to move on.

I asked Windy to go and get Mrs Albert's vase so I could catalogue it for the next sale. With my recent run of

luck I can't imagine why I risked it. I knew that when things are going badly they tend to go really badly. Windy made it all the way to where I was without mishap. Then he dropped it on to the table I was working at with all the delicacy of a country blacksmith. He just *dropped* it. I picked it up, praying there was no damage. I turned it carefully: all was well . . . until I looked at the base. There it was, in all its glory: a bloody great chip. I had no option but to phone her there and then. She was very good about it, really, all things considered. The trouble was I had to agree to pay her the £150 reserve, which was more than I thought it was worth. That certainly put an end to any romantic inclinations I might have had towards Albert. And it was the end of a rotten day when everything I thought I had to sell had evaporated or broken in front of me.

But that wasn't the end of the story. Some two weeks later there was a report in the local paper about a burglary at a house in Malvern. A gang had broken into Mr Smelly Man's house, beaten him up and taken all of the valuable contents. He had sold just one item and that had been for far less than it was worth. There should have been someone to protect him and others like him.

Chapter Fourteen

A Very Merry Monk

It was time to reacquaint myself with the interior of the Greyhound bar and meet up with Jim to discuss work in particular and how life was treating us both generally. I had figured by now that things would have moved on from the Albert fiasco, and I certainly had no intention of telling him how her mother's vase had been damaged while it was in my not-so-safe keeping. I drove into the pub car park and pulled up next to Jim's vehicle, which was beside a smart new sports car. I wandered inside and was somewhat taken aback to see Albert sitting next to him. I would have turned round and made for the door, had it not been for Jim's welcoming address.

'Bloody hell, stranger, we haven't seen you for some time. Mind you, I'm not too sure Rosemary will *want* to see you. First, you try to poison her and then you smash her mother's family heirloom.'

You could always rely on Jim in a time of crisis. I was about to make some comment that would probably have

dropped me deeper in it when there was a tap on my shoulder. It was Richard Bridges. The evening was getting better and better. I was about to say hello when, as ever, he beat me to it.

'Evening. We're just on our way, actually.' I wasn't sure who 'we' were, but I knew that Jim and he were not blood brothers . . . Slowly it dawned on me that Albert was the other part of his plural pronoun. 'I'm just taking Rosemary out for a spin in my new car. Did you see it outside?'

I looked at Rosemary: she seemed to be avoiding eye-contact with me.

Richard continued, 'Come on, Rosemary, we must go. Careful as you sit down, Philip – don't want you breaking anything.'

I admire sarcasm when it's done with a light touch, but not when I'm on the receiving end. Poor Albert seemed really embarrassed as she got up and walked past me. 'Don't worry. Mother was a little upset but I'm sure it wasn't your fault,' she said. They were comforting words, which didn't help much as the seemingly well-suited couple left the bar.

That left Jim and me, and all he wanted was all the gory details of the catalogue of catastrophes that had befallen me in the recent past. 'Well, it looks like you've really queered your pitch with Albert and let Richard in. Still, I suppose it was inevitable. Tell me what went on. Albert won't talk about it but I've picked up a few snippets here and there.'

I decided I'd gloss over the details and turn his attention to a new job that Mr Rayer had asked me to do, which I found really exciting. 'He's fixed me up with some paintings to go and look at tomorrow morning. I'm chuffed that he's letting me out more on my own.' Then I steered the conversation away from anything contentious, and eventually went home to look forward to my boss's new task. Tomorrow, I hoped, would be the start of better things in the Serrell life.

The next morning I set off to drive to a village in Warwickshire where I would see the paintings owned by an old client of Mr Rayer. My boss had told me that he was a man of the cloth to whom he used to sell pictures. The Reverend Henry Price lived, aptly enough, at The Rectory. I thoroughly enjoyed the drive and, for the umpteenth time, thanked my lucky stars for my good fortune. I was left pretty much to my own devices, paid to drive around glorious countryside and meet fascinating people. Most importantly, I had a boss who indulged and put up with me.

The village was on the edge of the Cotswold escarpment and had many handsome houses built of local stone. The rectory would undoubtedly be an imposing mansion next to the village church. I pulled up beside the church and, sure enough, next door to it stood a magnificent eighteenth-century three-storey house, built not of local stone but of mellowed brickwork. There was even a metal plaque on the gate, which proclaimed 'The Old

Rectory'. Close, but not close enough. I drove on a little further and, sure enough, there was another sign, this time painted in white on a wooden blackboard. It proudly proclaimed the entrance to 'The Rectory'.

I drove in, and there was the *new* ecclesiastical residence in all its glory. God, it was grim. It was all that was bad about planning in the late 1960s and early 1970s. The elevations were constructed of the most dreadful wire-cut facing brick under a concrete tiled roof. The problem with the roof was the colour of the tiles: in an attempt to blend with the rustic surroundings the builders had used a pale red that had turned a vivid pink. The whole scene blended in like a Portakabin at the entrance to Buckingham Palace. This carbuncle had been built in the exquisitely manicured grounds of the Old Rectory. Its own grounds, however, weren't quite so well tended. The grassed, lawned area looked like a shabby cowfield that a tractor with a flail would have struggled to cope with, let alone a lawnmower. The flower borders were something else: there were no flowers, just piles of rotting vegetation that made the whole lot look like a record attempt at the world's worst compost heap. Outside the front door of the house were the Reverend's two cars: a Maxi with two flat tyres and furry dice hanging from the interior mirror, and an old Austin Cambridge that had as much foliage growing around, under and out of it as the flower borders lacked.

I made my way to the front door, stepping over three

boxes of empty wine bottles that looked as if they had been there for years rather than weeks or months. The Reverend clearly didn't dispose of the communion bottles quite as often as he perhaps should.

There was another interesting feature round the front door: the concrete lintel had a huge crack and was supported by an Acrow prop, which was holding the whole lot up. A copper bell, which, from lack of polish, was a sludge green, hung from the top screw section of the prop. It was clearly the doorbell so I gave the string that dangled from it a hearty tug, then wished I hadn't as the contraption hit my head. I don't know which rang louder, my head or the bell, but at least I could see through the bull's eye glazed door that someone was walking towards me. The door opened. It was the Reverend. He looked just like Friar Tuck from the 1950s Robin Hood television series, except that he didn't wear the typical cassock. He stood about five feet six and looked to be about five feet five wide. He had ruddy cheeks on a moon-shaped face, a Beatle hairdo with a plate-sized bald patch on the top of his head. His most striking feature, however, was his nose: gnarled like a growth on an old elm tree, it was plum-coloured, and he looked like Falstaff.

Don't know howsh you rung the bell, hic . . . Ish been broken for agesh.'

Half-way through his opening sentence I wondered if he had a speech impediment. By the end, and taking into

account his 'ruddy complexion', I realised that any impediment was alcohol-induced. Perhaps the three boxes of empty bottles should have given me a clue. And he was no amateur tippler: it was only about ten thirty in the morning.

'Ted shent you . . . to look at the picshures. Do come in – we'll have a little drink.'

I made my way inside, presuming tea or coffee was not on the menu, but I had little chance to answer. The interior wonderfully complemented the exterior of the house. There were bags of rubbish everywhere and 1960s furniture that was more of a liability than an asset. The walls, however, were something else: they were lined with the most glorious watercolours and oil paintings.

'I'll get ush a drink.' 'Friar Tuck' turned on his heels and swaggered, slightly, down the hallway as I was about decline his kind offer. I had a long way to drive, and even though I enjoyed a drink I preferred to do my imbibing before eleven *p.m.* rather than *a.m.*

He wandered back, bouncing off the hall walls like a bobsleigh team on the Cresta Run. 'Good for the shoul. The good Lord after all turned water inshto wine.'

Well, he might have had the approval of his boss but I was left holding a half-pint of dodgy white wine that smelt like turps. Tuck was slurping at his as he walked and we meandered into the sitting room, where the walls were also covered with lovely paintings.

'Theshe are the three I want to shell. An Oliver Clare, a

Milesh Birkett Foshter and that Old Mashter School over there,' he said, pointing to a landscape that looked, to my untutored eye, old and possibly Italian. The Oliver Clare was typical of his work: he was from a family of Birmingham painters who included Vincent and George. (I didn't know it at the time but there was a certain irony in that Oliver had enjoyed a drink and would occasionally swap his work for a pint at the local.) They were prolific in their production of small still-life oil paintings of plums, berries, pears and apples against a mossy background. Miles Birkett Foster was well known for his pretty watercolours of children in landscapes. The Old Master School was a bit of a mystery to me.

All three paintings measured about ten inches by twelve and would be easily transportable in the back of my little Mini. I felt I ought to make some remarks about them, but decided to say nothing and let Tuck, who, after all, was a collector and, like all collectors, keen to talk, impart his knowledge to me. The silence that followed was short as my client shared his enthusiasm for his paintings. 'Bought the Clare and the Foshter from Ted. They each cosht me about sixsh hundred pounds five or sixsh yearsh ago. The Old Mashter landshcape I bought from a big country-houshe sale about twelve yearsh ago. Cosht two hundred pounds – no one wash there, I wash jusht lucky. Take them and shell them for me.'

As he took the paintings off the wall, I tipped the contents of my glass into a plant pot that contained a

withered geranium. I wondered if its condition was due to lack of attention like everything else in and outside the house, or whether it had suffered alcohol poisoning from other guests who had dispensed with an unwanted drink.

I thought I had better try to offer some professional advice. 'Would you like us to put reserves on the paintings, sir?'

His negative response was immediate and, in this instance, particularly welcome. If he had said yes, I'm not sure what I would have done. I was sure I could find out about the Clare and the Birkett Foster, but where to start with the third painting?

'No, jusht put them in the shale – I'm shure they'll make what they're worth. Jusht put them in the firsht shale you can. Chrishtmash can be a little coshtly and the fundsh would be usheful. Would you like another little drink – one for the road?'

That was the last thing in the world I wanted. I took the three small paintings from him and left the house. I was through the door and nearly in the car when Tuck waved goodbye with his glass and shouted, 'Cheersh, thanksh sho much for coming.'

His speech was getting more and more slurred and I was left with another important lesson for the future. If you have a client who 'enjoys a drink' it's always best to make an appointment as early as possible, before the effects of a day's tippling take effect.

I drove back to the saleroom, looking forward to

cataloguing the paintings. The sale was due to take place ten days later so there was just enough time to advertise them and include them in the A4-sized catalogue that we produced the day before ('catalogue' was too grand a word, really, it was more like a list.) There was little else in the sale of any particular merit: Christmas was coming, and many clients felt it prudent to wait until the new year. When the catalogue was ready, I felt pleased with my descriptions.

> Lot 114. Oliver Clare – Oil on Canvas – Still life study of plums and fruit on a mossy background, 10 inches × 12 inches.
> Lot 115. Miles Birkett Foster – Watercolour – Children in a bluebell wood, 8 inches × 14 inches.
> Lot 116. Old Master School – Oil on Panel – Continental Landscape, 14 inches × 16 inches.

The viewing day arrived and I was delighted with the response to my adverts as the three little paintings attracted a lot of attention. My estimate for the Clare was £800–1200 the Birkett Foster £1,000–1,500 and, with a bit of guesswork, £300–500 for the Old Master, about which I was completely in the dark. I had had to base my estimate on what Tuck had paid for it.

All of the dealers seemed interested in the landscape and I was confident it would make my estimate; a dealer and a collector had already booked telephone lines to bid on the Clare so all looked good in that respect too. The

Birkett Foster seemed to be in the bronze-medal position of the three. A lot of dealers picked it up and put it down straight away; canny lot, I thought, trying to keep their interest to themselves and not let the opposition – the auctioneer – know their intent (really I should have learned from the Hester Bateman bowl). I respect the knowledge of specialist dealers hugely: they travel many hundreds, if not thousands, of miles each week, searching for the hidden gem in a small saleroom that has gone unrecognised by everyone else. Their knowledge can produce some spectacular results but it is only the accumulation of many years' hard research and their ability to put their money where their mouth is that produces such results. I was feeling confident that Tuck would be pleased with the sale and went home that evening looking forward to the auction the next day. I was feeling so chirpy that I decided to call in at the Greyhound and have a swift half with Jim. As ever, he was not shy in coming forward with an opinion.

'Well, I don't reckon Richard Bridges is going to be a permanent fixture. Albert said he almost forced her to go for a drive in that bloody new crumpet-magnet he's got. She seems a really nice girl. Pity, I bore her – and you've tried to poison her as well as destroying her family heirloom. Rules us out. Get me a half.'

In the morning I drove to work, still looking forward to the sale. I arrived at about eight thirty to find a number of dealers waiting on the doorstep of the saleroom eager

to be let in. The majority made straight for Tuck's paintings, which boded well for a successful day. I could hardly wait for them to be offered for sale. None of the dealers had given any hint of what they might make but interest centred on the Old Master. Eventually, after what seemed like an eternity but was in reality about an hour and a half (would I ever learn to judge time accurately? But, then, I didn't have the best tutor) we arrived at the lots in question.

First up was the Oliver Clare; the bidding opened at £600 and a battle developed between the collector and the dealer, both on the telephone. The hammer eventually fell to the collector for a pleasing £1,450. That represented a good profit on what Tuck had paid for it. One down and two to go.

Next was the Birkett Foster. Tuck had paid £600 for it, and none of the serious dealers or collectors seemed keen to bid anywhere near that. Mr Rayer was not a man to get flustered: he plugged away and eventually the bidding was opened by a local amateur-dealer type who bid what I thought was an optimistic £100. I surmised that a bidding war would intensify after the opening bid and we would soon break the four-figure barrier. However, although Mr Rayer used all of his skill to extract another bid, no one else put their hand up and that was the end of that: sold for £100. That certainly balanced the scales a little. I wondered how Tuck would take the news of his Birkett Foster going for so little.

Sold to the Man with the Tin Leg

Finally it was the turn of the landscape: would it make the three hundred pounds I had estimated? I was caught with my trousers down when the bidding opened immediately at my bottom estimate. It rocketed through the thousand-pound barrier – and on it went, and on it went: two thousand, three thousand and finally the hammer came down at £4,200. I was delighted and I was sure Tuck would be too.

After the sale I decided to have a chat with one of the local picture dealers to see what he thought about the three paintings we had sold.

'Well, Philip, the Clare made what it was worth. The Birkett Foster was a complete Sexton Blake – Cockney rhyming slang for fake. Of every ten you see eleven are wrong. And the landscape was a bit of a sleeper.' A 'sleeper' is a lot that has gone unrecognised by the auctioneer and sometimes sells, unexpectedly, for what it is worth and on other occasions will make a fraction of its real value only to be sold later for its true worth, sometimes a hundred or a thousand times more than the original purchase price. The question here was, had it made what it was worth, or had the firm sold a rare Old Master for a fraction of its true value? I was destined never to find out the answer to that question; I'm not sure I wanted to know. I didn't ask my dealer friend and he didn't offer to tell me. Mr Rayer's view, as usual, was that the paintings had made what they were worth. His client Tuck was an experienced collector and he felt that

the failure of the Sexton Blake was more than offset by the sleeper.

I thought I had better call Tuck and let him know the sale results. It was by now late afternoon and the day had clearly taken its toll: 'Absholutely delighted. Should ensure a merry Chrishmas.' And it struck me that Christmas wasn't the only time that was merry for the Reverend Henry Price.

Chapter Fifteen

The Cup Overfloweth

Christmas came and went pretty much as usual with socks, sweaters and aftershave that no one in their right mind would wear – other than me – unless they were in the company of the individual who had chosen the gift. Year after year it had confused me why a family of three, like mine, would buy a turkey the size of an ostrich that took days to eat cooked in every guise known to mankind. It's pretty obvious to me why it's on the menu only once a year. New Year's Eve was also pretty much the norm: again a journey of expectation resulting in the arrival of disappointment – it promises so much and delivers so little. The year ended with Jim and me getting maudlin with a Party Seven can of warm beer. I was looking forward to getting back to work, even though I had been working until six o'clock on Christmas Eve with Mr Rayer. Christmas Day was one of the rare days when even he had to stop working: he seemed to view this with reluctance, although he enjoyed a party and was

perfectly capable of acting like a fourteen-year-old in the presence of a matronly maiden aunt when he got going.

So it was back to the saleroom and auctions to organise. I was trawling through the boxes of smalls that appeared daily in the saleroom when one of our regulars appeared. Mrs Flower was a lovely lady who attended most of our sales as a buyer. When it came to purchasing power she was not up there with the Getty Museum: she rarely spent over twenty pounds on anything, and her house, although I hadn't seen it, was by repute and her own admission full of inexpensive and not particularly collectable 'tat'. She, like many saleroom devotees, was what might be described as a tad eccentric. The less kind would swear blind that she had been hit by every branch as she fell out of the madness tree.

She was about sixty-five and always wore a pink headscarf with a long pink floral coat and wellingtons, whatever the weather. Her most striking feature, however, was her bosom, which was like a dead heat in a zeppelin race. It appeared to start immediately below her shoulders and end just above her waist. It was pneumatic, not in the manner of the pin-up but in the way that it sailed through a door a few seconds before the rest of her did. She was a sweet lady who, the first time I had met her, appeared on a non sale-day clutching a large biscuit tin. Her arms were just long enough to go round the tin and her chest, and I assumed it contained some valuable silver or a small piece of porcelain that she wanted to sell.

Now, a lot of people regard salerooms as drop-in centres where they can call in for a cup of coffee and a chat, and very welcome they are too. Mrs Flower, I discovered, was one of those.

'Morning! Can I help you?' I asked, waiting eagerly to assess the contents of the tin.

'Well, yes, dear, I've got this for you.' She glanced down at her front.

I assumed she was referring to the tin. 'Certainly. Let's open it up and have a look.' I took it from her, conscious it might contain a piece of silver worth a thousand pounds or, if I was unlucky, a worthless piece of china thought by its owner to be as valuable as the Crown Jewels. I placed it on the table in front of me and gingerly took off the lid. Would it be the priceless gem or the fairground china?

It was neither. The tin contained a cake. I was confused and not entirely sure what I was supposed to do with it. Anything was possible with some of our clientele. I recalled one such occasion when a gentleman had brought a potato into the saleroom. When I looked quizzically at him he asked me if I thought it was old. I said I didn't think it was, to which he replied that he thought it was King Edward's. At that he had burst into fits of laughter, turned on his heels and vanished, never to be seen again. I was thinking that Mrs Flower might be about to ask me the same question only to tell me it was a Victoria sponge. But no.

'I love coming to the sales so much and I thought I'd bring you this cake to have with your coffee as a thank-you.' What a lovely lady, I thought, and took her into the office where I made us both a drink. I offered her a mug of coffee and a plate, which elicited the response, 'No, thank you, dear, I've brought it for you.' How sweet. It really did look good and I thought a slice with my coffee would be just what the doctor ordered.

Looks, however, may prove deceptive. I don't know which recipe she'd followed but I reckon it came out of a DIY tome rather than a cookery book. The ingredients appeared to be two of sand, three of cement. The finished article certainly took some cutting. A hammer and chisel would have been more useful than a knife, but after a lot of effort I eventually got through it. Mrs Flower simply sat there and smiled at me. I decided to take only a small piece. A wise decision. For some reason only the outer shell was tough, the inside was soft and crumbly. I took a bite. 'Dry' wouldn't begin to describe the consistency. Two mouthfuls and I would defy anyone to whistle two choruses of 'Rule Britannia' without spraying everyone within a three-foot radius with what tasted like concrete dust.

This was the first of Mrs Flower's regular appearances in the saleroom armed with a tin that contained some culinary disaster. The tin, followed by the balloon-shaped part of the pink floral coat, was to become a familiar sight.

She arrived this January day in the customary coat, headscarf and wellingtons, clutching the customary tin. I had just about got over the excesses of Christmas and was a little daunted by the prospect of eating another of her building-site cakes.

'Here you are, dear. Could you put this in one of your next sales?' For a brief moment I wondered how well one of Mrs Flower's cakes would do, but when I opened the tin I saw, with some relief, that, rather than a cake, it contained numerous trinkets, small bits of the aforementioned fairground china and other odds and ends. 'Put it into your next sale without reserve, dear. I don't expect it'll make much but I'm starting to clear out some of the things I've bought here in the past.' I prepared the necessary paperwork and bade Mrs Flower farewell.

After she had gone I went through the tin and, sure enough, nothing seemed to be particularly valuable but there was a small thing, like a vase, which I thought might be interesting. I didn't know what it was, but had a feeling that it would sell as a separate lot. It was brown, and about three inches high. I was a little concerned that I hadn't the first idea what it was made of. It was neither metal nor pottery but more like a type of ivory and, at a guess, was eastern in origin. I was also unsure as to its age, but the more I looked at it the more interesting it became. Mr Rayer occasionally let me sell some of the lesser items in the sale but I had a hunch that this was not

going to fall into that category. I decided to offer it for sale on its own and put up the rest as a job lot.

The view and sale days brought the usual amount of interest in the many and varied lots, but Mrs Flower's little vase created a stir. I still didn't have the first idea what it was but eventually a charitable dealer put me out of my misery. 'It's a rhinoceros horn libation cup. Eighteenth century, Chinese. Don't worry, it's not worth a fortune but should make its money – five to eight hundred pounds. They were ceremonial cups.'

Well, that was another occasion when I felt completely inadequate. I hadn't had the first idea what it was but at least I had had the foresight to pull it out of the tin.

The dealer was spot on with his valuation; the libation cup sold for £820 while the biscuit tin with the bits and pieces made £18. There was no doubt that Mrs Flower would be delighted when she got her cheque. But that was where my problems started. When I had pulled the cup out of the tin I had forgotten to put Mrs Flower's reference on it, and only discovered this when Hinge and Bracket had written all the vendor's cheques for the sale and the libation cup was left over with no name. Still, disaster was averted, because we hadn't paid anyone else for it and it was simply a matter of writing another cheque for Mrs Flower. That all seemed fairly simple: she would get two cheques and would no doubt be delighted with them.

About four days later a large pink bosom appeared in

the doorway of the saleroom office, announcing the imminent arrival of Mrs Flower. Today, however, there was no tin clasped to her ample proportions, which appeared to be shaking like the world's biggest jelly. Mrs Flower came in, clearly upset. 'My dear, something dreadful has happened.' Not the words that an auctioneer wants to hear, and guaranteed to send a cold shiver down the spine. I guessed she hadn't realised the libation cup was in the tin box and hadn't wanted to sell it. How on earth was I going to get out of this one?

'What's the problem, Mrs Flower?' I asked, sure I knew the answer already.

'Well, dear, you've sent me two cheques for the sale and one isn't mine. There's been a dreadful mistake. I only put the tin box into the sale, which made eighteen pounds, and this other cheque is for something that sold for eight hundred and twenty.'

What a relief. I had only to explain what had happened and all would be well. I told her the whole story and expected a wave of gratitude to appear on her face when she grasped her good fortune.

'No, dear, it isn't mine. I've never owned anything as valuable as that in my life. You must have the cheque back and pay the real owner. It's been worrying me to death.'

She put the cheque down on the counter and walked out of the office. I followed her, trying to assure her that it really was her money, but she simply wouldn't listen.

This was a new experience for me: many vendors complained that they had not received enough money or that we had not accounted for all their lots, but no one had ever said we'd paid them too much. I decided I would write her a detailed letter, explaining the situation and enclosing the cheque, which she would then realise was her money. When I'd finished, I thought it was a masterpiece and should do the trick. Wrong. Back came the cheque by return of post with a short note saying, 'This is *not* my money.' I knew beyond all doubt that it *was*, but how was I going to convince her? It was time to seek Mr Rayer's advice.

'Well, Philip, it might have been a good idea to phone her when you pulled the horn cup out in the first place, but leave it to me and I'll see what I can do. I know who her lawyer is. I'll have a chat with him and we'll pop round and see her.'

True to his word Mr Rayer convinced Mrs Flower that it was her money and the cheque was finally banked. Then he told me why she was so convinced it wasn't hers. 'Apparently, Philip, old Mother Flower bought the little tin box and contents at an auction about eighteen months ago. She paid twelve pounds for it, took out two horse brasses that she wanted and decided to put the rest back into a sale. You did well to spot that horn cup.'

Mr Rayer looked at me, eyebrows raised. I nodded – I was pleased I'd spotted it but anxious that I hadn't had any idea of what it was. I still had so much to learn. But

Mr Rayer was still looking at me, and suddenly I knew what he was driving at. Wherever she had originally bought it had missed it the first time round . . . Had she bought it from *our* saleroom? I couldn't remember.

Did Mr Rayer know? If he did, he never told me. Neither did Mrs Flower.

Chapter Sixteen

The Course of True Love Never Did Run Smooth

Life was fairly quiet in the saleroom for the next few months and my social life continued to make a monk's look like Peter Stringfellow's. There had been only a sniff of romance in the air when Jim and I had arranged a dinner date with two girls. We had met them in the Greyhound and thought it would be jolly if the four of us went out together for a meal. And indeed it was: we all seemed relaxed and happy as we ordered our meal. I should have known by then that assumptions are dangerous. As usual Jim and I were skint and had just about saved up enough funds to pay for ourselves. We decided to treat ourselves to smoked salmon followed by a good steak with an expensive bottle of wine. The wind was somewhat blown out of our sails when one girl piped up, 'It's really kind of you to treat us both like this.' Jim and I looked at each other with horror. Our appetites waned as we changed our order to the cheapest of everything on the menu: soup followed by chicken, no pudding and a

ropey bottle of white wine. The girls, of course, ate well and, after a tense few moments while we settled the bill, Jim and I left the restaurant with only a few coppers between us. We never saw the girls again.

I was sitting in my office in Worcester one day soon after this near-disaster when the internal office phone rang. (Mr Rayer was struggling to come to terms with the new telephone system that had replaced the old contraption of pipes and whistles.)

'Philip,' Hinge announced, 'there is a call for you on line one. It's Rosemary Hall.'

Bloody 'ell, I thought. Albert. After my various débâcles with her I had decided to keep my head well down and hadn't seen too much of her. I assumed she was still being squired around by Richard Bridges. I answered the phone nervously, horribly aware that everything else I had said to or done with the poor girl had ended in disaster and I really didn't want to mess up again.

'Philip, I know this is an imposition but my car broke down this morning and had to go into the garage. I wondered if you could give me a lift home tonight?'

Do fish swim? Yes, was the immediate answer, but I thought I'd better play it cool and paused for a moment.

She interrupted the silence: 'If it's a problem I'm sure I can get someone else to help out.'

'No, no, no, not at all.' Now I sounded too keen. 'Come down to the office after work and it'll be no problem.'

Suddenly life was a whole lot rosier. Then the phone buzzed again. It was Mr Rayer. 'Philip, can you bring me doings's file?'

My apprenticeship had taught me many things and the ability to interpret who 'doings' was and which file Mr Rayer wanted was a black art that I was becoming well versed in. This time I got it right on the third attempt.

Mr Rayer's desk top looked as it always did: as if vandals had broken in while he wasn't there and trashed all of the files, books and paperwork on it. My biggest concern at the moment, however, was that my ever-considerate boss would have some important assignation for me in deepest Wales for which I would have to depart straight away. And I was not going to be anywhere other than at the office when it came to going-home time – normal going-home time, that was, not Mr Rayer's going-home time. I decided that the best form of defence was attack and left Mr Rayer in no doubt that my presence in the office at five o'clock was a matter of world importance.

'Mr Rayer, I've arranged to give the young girl from Lloyd and Gold a lift home. Her car's broken down. Apparently she has to be home on time because her parents are taking her out.'

I thought I detected a twinkle in his eye as he said, 'That's very kind of you, Philip, very gallant, with no thought at all for yourself.' Dai, at Mr Rayer's side, was less subtle. He chuckled.

As it was quiet in both the saleroom and the markets, Dai was in the office acting as the Galloping Major's batman, resembling nothing so much as a faithful old Labrador. Mr Rayer, with fewer than twenty-five years left of the twentieth century, had decided it was time to embrace modern technology and had bought himself one of those 'new-fangled dictating machines'. Being Mr Rayer he hadn't bought a simple, battery-operated device but had chosen a complex machine that would have tested the skills of NASA technicians. It was pitiful to watch the two of them try to wire it up. I was amazed they had both made it through the war, let alone life thereafter. I put doings's file on his desk and slipped quietly out of the office as Mr Rayer lit his pipe and said, 'No, Dai, this gubbins fits the doings over there but I'm not sure what this bit of spare wire does.'

I suppose it was better to have a bit of wire left over than be a bit short.

I made sure I was conspicuous by my absence for the rest of the day, busying myself with 'errands' around town and hiding in the office. I reappeared in the reception area as five o'clock approached to find Hinge and Bracket gathered at the rear desk, each with a cigarette in hand and lemon tea to one side, trying to work out Mr Rayer's new box of tricks.

'Philip, just listen! Giving him a machine like this is as dangerous as giving a monkey a shotgun.' Hinge pressed

the start button and Mr Rayer's dulcet tones came through the loudspeaker.

'Er, this is a letter to gubbins – er, Dai, can you pass the doings from over there? Thank you – er . . .' There then followed a lot of puffing and a noise like a washboard player in a skiffle group: it was Mr Rayer lighting his pipe, using at least one box of matches. 'Dear . . . damn . . .' At this point I think the bowl on his pipe had dropped off again as there was the familiar noise of him tapping out the burning embers. '. . . er, with ref to . . . Damn! Dai, this is the wrong doings . . .'

And on it went. Mr Rayer had located the start button but, seemingly not the stop. He had used a whole thirty-minute tape to dictate an eleven-line letter. How Hinge and Brackett would cope with this new labour-saving device remained to be seen. At least it had kept Mr Rayer and Dai busy for a while.

Having kept my head down for most of the day, I was in the right place to greet Albert when she walked into the front office at five past five. She had finished at five o'clock, while I had to work until half past. She looked stunning, with a beaming smile that lit up her lovely face and those striking eyes. I gave her the keys to Ooby, which was parked behind the office, and told her if she waited for me in it I would be out shortly. Terror struck my heart as I heard Mr Rayer coming down the stairs. The door opened and Dai walked through first. Mr Rayer bade him good evening and went out into the

car park. Now I was nervous. I stood there staring at Mr Rayer. I knew that at any minute he would ask me to do something that would mean Albert sitting in the car park for about two hours waiting for me. After what seemed an age he opened his mouth: 'Thought you had to give that girl a lift home. Go on, off you go.' I could have kissed him. Nothing could go wrong now.

My car was parked at the far end of the dark car park and I could just see the silhouette of Albert sitting in the passenger seat. But, oh, my God, she wasn't on her own: Dai was standing against my front offside wheel, hands cupped together just below his belt buckle. I couldn't believe my eyes. He was having a pee. I coughed loudly. Dai looked up, waved, finished the business in hand and bade me a cheery good night. I went up to my car, careful to avoid the small stream at the front, opened the door and climbed in. I didn't know *what* to say. Albert didn't say anything so neither did I. Our journey to her parents' house was as quiet as the one from the gala dinner. Never mind not getting off the ground, this relationship was still in the departure lounge with the flight looking as if it was about to be cancelled.

Chapter Seventeen

Things Might Turn a Little Nasty

After Dai's antics, I reassumed the low profile. I didn't even want to contemplate what Albert had thought of the incident. The Galloping Major came to the rescue with another diversion. This time it was a sale on the vendor's premises, but not of the usual type where we were acting for a deceased estate or a client who was selling up. This was a sale for a liquidator where all the assets of a particular company had to be sold on the premises to help repay the creditors. The company was an organic farm in deepest Shropshire; this being the late 1970s, the farmer was clearly some way ahead of his time in farming methods. Experience gained later in life tells me that anyone so advanced in their thinking must have been either a genius or doomed to failure. Clearly this farmer was the latter.

Mr Rayer asked me to meet the full team – Dickie, Dai and Windy – to help set up the sale and gave me precise directions on how to find the place. Apparently you

turned left off the doings road, down past where old thingy used to live, right by the pub on the corner, on towards the farm that had the foot-and-mouth outbreak back in the sixties, then straight over the crossroads where there was that bad accident and, finally, down the lane to where old Farmer Gubbins lived whose wife grew prize roses. Simple. The trouble was, if you asked Mr Rayer to be precise on how to get somewhere he merely gave you more that simply clouded the issue. There, I was to see a certain Claude Young-Clarke: the forward-thinking farmer whose business had failed.

Mr Rayer told me it was about an hour's drive from Worcester so I gave myself two and arranged to meet my three intrepid helpers there. I was now in Ooby driving along the same lane for the fifth time trying to follow Mr Rayer's directions when a strange vehicle lurched towards me, clouds of smoke spewing out of the back as it listed to one side like a holed ship. It was Windy's home-made half-timbered Austin 1100, which seemed to have developed a similar exhaust problem to its owner. He stopped in the lane in front of me and got out. He was clearly not happy.

'The old girl's always run like a watch. Only ever 'ad me and the missus in 'er and now these two 'ave over-stretched 'er.'

I could see what he meant: neither Dickie nor Dai could have been recruited for the 'after' part of a WeightWatchers campaign. Between them they must

have touched the scales at nearer to thirty-five than twenty-five stone, and had both sat on the same side of the car, hence the list.

'The old girl's a collector's car not a transporter for those two lumps.' I had never seen Windy quite so vociferous about anything. He was hopping from foot to foot in fury and his upset was making him 'parp' away at a much quicker rate than normal. 'And bloody Major Rayer couldn't direct traffic, let alone tell us how to get out here. We've been driving up and down this road for twenty minutes now and my little Austin won't take much more.'

At that point a tractor and trailer pulled up behind Windy's car. As there was no way that the driver could pass either my car or Windy's he was the ideal person to ask for some sensible directions.

'You wants old Claude's place.' The man was clearly a genius. ' 'E ain't over pop'lar round 'ere. 'E owes money, 'e do – bin wun o' they orgasmic farmers – never gonner catch on that, you can't grow nothing without proper kemicals. You 'as to 'ave fozfates an' 'e wouldn't 'ave none o' that. 'E en' 'arf upset a lot o' people, tho' – 'e done 'arf owe some money round these parts. See . . .' This had the makings of a very long speech. I decided to interrupt in an attempt to get some directions to the farm.

It transpired that we were about two miles from the 'orgasmic farmer' with me facing the right direction and Windy needing to perform a one-hundred-and-eighty-

degree turn. He climbed back into his car, muttering, while the other two stayed wedged into the passenger side. He fired up the Austin and, amid a cloud of smoke, executed a perfect forty-eight-point turn in the middle of the narrow lane and we set off in convoy.

As we turned down a farm track as directed I had to brake sharply to avoid a sign that was lying on the ground in the middle. It proudly proclaimed 'The Shropshire Organic Farming Company Limited, Director: Claude Young-Clarke Esq.' Rather unkindly, I thought, someone had painted a line through his name and had scrawled Cheating Old B*****d instead. We were obviously at the right place.

Claude was about fifty-five and impeccably dressed; I had never before met a working farmer who wore an expensive tweed suit on the farm. I told him that we had had a bit of trouble finding him but we had eventually found the lane with the sign in the middle of it.

'Yeth, the localths have weacted wather badly. They clearly have no thenthe of commercial withk. In buith-neth thereth alwayth the chanthe of lothing money.' He then went on to to tell me that he couldn't understand why all the locals didn't trade as limited companies. 'After all, thereth no thenthe in withking your own money, ith there?' We walked up to the farmhouse where a top-of-the-range Mercedes Benz motor-car was parked. Insolvency seemed to have had little effect on Claude Young-Clarke except that, with his lisp, he would have

had a hell of a job pronouncing it. Claude explained to me that he felt farming should change: in his view organic farming really was the future and that natural manures were the thing to fertilise the soil, not chemicals.

Our task was quite simple, really: all we had to do was lot up the farm implements and machinery as fast as possible, ready for sale at short notice. A lot of insolvency sales are conducted on this basis, the underlying principle being that time is money, and the longer it takes the more it costs. This was the prime reason for the whole of the Bentley, Hobbs and Mytton sales preparation team being out on the job *en masse*. It was clear that my workforce, even with their extraordinary skill at turning a small task into a mountainous one, would have this one licked into shape in no time at all. There were only going to be about two hundred lots and it was just a matter of sorting out a sale date with Mr Rayer back in the office.

'Well, Philip, I think we may as well have the sale two weeks on Friday. From what you say you'll be ready well in time for that.' I couldn't see a problem with the time scale and was about to agree when I caught sight of the calendar hanging on the wall. Mr Rayer noticed my concerned look and continued, 'Is that day a problem, Philip? Have you got yourself a date with that girl from Lloyd and Gold's office?'

Chance would be a fine thing: Albert and I weren't so much ships passing in the night as sailing round different

oceans. 'No, Mr Rayer, it's just that it's Friday The Thirteenth.'

'What's happening then? Have we double-booked an appointment?'

'No, Mr Rayer, it's just that it's *Friday* The Thirteenth,' I repeated timidly.

'I still don't see the significance. Where's the problem if we haven't double-booked?'

I was beginning to wish I'd said nothing. Mr Rayer clearly didn't do superstition and it was another conversation destined to go nowhere. The sale was going to be on Friday The Thirteenth no matter how many fates I felt we were tempting. I knew we would be doomed – it was just a question of what would go wrong.

That evening I called at the Greyhound for a swift, or slow, half with Jim. He was on top form as his boss was involved with a pipeline claim and wanted Jim to help. Jim saw this as a real opportunity. Strange, really, but I couldn't work up as much enthusiasm for pipelines as Jim could – it's a good job we're all different. I asked him how Albert was.

'Well, it's funny, really, but I reckon she likes you. Whenever your name's mentioned she doesn't say much but she smiles a bit.'

I told him I reckoned her smile was probably more of a nervous tic. Jim, rather unkindly, I thought, retorted that it might be wind. To date I had made her sick, destroyed one of her family heirlooms, allowed one of my work

colleagues to expose himself to her and generally made an ass of myself. No, I think that in her eyes I'd probably cooked my whole flock of geese.

I went on to tell Jim about my concerns for the doomsday Friday The Thirteenth sale.

'Well, I reckon that's asking for it. Life's bloody hard enough without going looking for trouble.' His words were not comforting.

The worrying thing was that things were going swimmingly at the orgasmic farm. The sale was well on the way to be lotted up in time, which, in itself, was a rarity for Ten o'Clock Ted.

At about twelve noon we were sitting in the barn – and it was still two days before the auction – when our host appeared. 'I thay, would you like a honey and lettuthe thandwich? It'll fill a little crack.'

This was all a bit new age for Windy, Dai and Dickie: it smacked of sandals and hairy legs. On hearing of our kind host's offer, the three promptly decided to head for the local pub. I felt, as a matter of courtesy, that I ought to stay and enjoy lunch with Claude. I have to say that honey and lettuce was something of an acquired taste that my palate was not quite ready for.

'Philip, I know the company'th in liquidathion but I thuppothe I can thtill buy thome of the lotth.'

I wasn't sure what the answer might be to that question but said I would check with Mr Rayer. It was clear that Claude Young-Clarke's main concern was for num-

ber one: not once during any conversations did he show any semblance of remorse for the financial hardship he had inflicted on his neighbours.

After about an hour the Three Musketeers returned, with just a hint of beer on their breath. Dickie had a quiet word in my ear. 'You know, Phil, he ain't half upset some of the locals. They can't understand how he can owe tens of thousands of pounds – mostly to his neighbours – when his own lifestyle hasn't changed at all.' It's a common misconception that the directors of a limited company are personally responsible for a company's debts. Put simply, individuals are declared bankrupt and limited companies are placed in liquidation with their debts limited to what the company can pay. 'They're all going to boycott the sale and hope the stuff sells for nothing,' Dickie finished.

So that was how it would all go wrong on the dreaded Friday The Thirteenth.

Back at the office I mentioned to Mr Rayer that Mr Young-Clarke had expressed an interest in buying back some of the company assets. His reply was as phlegmatic as normal: 'His money is as good as the next man's, Philip.'

The sale was lotted up and notification sheets had been sent out to local farmers and other interested parties. Worryingly, Mr Rayer had had directions put on the sheets using his new-fangled dictating machine. By comparison his directions on my first trip to the farm had

been clear and concise. He had even gone to the trouble of having a number of 'To the Sale' signs painted; it was to be my job to put them up on the morning of the sale. Mr Rayer was clear that, as the sale was so small, there was no need to have viewing the day before. It really was most unlike a Mr Rayer auction: everything was numbered consecutively and in order, the rows of lots out in the fields were nice and straight and all was ready.

Yet by the evening of the twelfth my nerves were shot to pieces. Our extraordinary state of readiness did nothing to dispel my fears: I just wanted to get to the fourteenth as soon as possible. I set my alarm for five o'clock anxious to get to the farm as early as possible.

When I opened my bedroom curtains, I saw that the Friday The Thirteenth jinx had struck: what seemed like three feet of snow had fallen overnight. It wasn't forecast but there it was, a white blanket everywhere. I hurried to get dressed and made my way to the orgasmic farm.

To my relief, I found the roads weren't as treacherous as they might have been. Maybe some punters would get through. I even had enough time to put up the signs. It was now eight thirty and clouds of smoke signalled the arrival of Dai, Windy and Dickie in the Austin 1100.

Dickie was first to greet me. 'Morning, Phil, thought you were going to put the "To the Sale" signs up?'

'I have,' was the only possible response.

'Well, some bugger's taken 'em down, then. You'd best go and check 'em,' Dickie retorted.

Off I set, only to discover that he was right and every one of the five strategically placed signs had been up-rooted and thrown either behind the hedge or in the ditch. Painstakingly I put them all back up again and returned to the farm.

It wasn't long before Mr Rayer appeared in Thunder-bird IV. He had an interesting driving technique in the snow: it consisted of throwing all caution to the winds and gunning the accelerator as hard as possible. This led to a trajectory that left tracks similar to that of side-winder snakes in natural-history films. Lot forty-seven, a two-wheel trailer, stopped the sliding Triumph and Mr Rayer subsequently climbed out, unruffled, as though everyone parked in a similar fashion.

'Morning, Philip. Thought you were going to put up the "To the Sale" signs?'

Was this a delayed echo? I explained that I had indeed put them up, *twice* so far this morning, but that I would go and check that all was in order – again. I retraced my steps in Ooby and, sure enough, the signs had once more been uprooted and discarded. I replaced them all yet again and made my way back to the farm for a third time.

The sale was due to start at ten thirty and so far we had five members of staff on site with one director of a liquidated company and no punters. This was not look-ing good. Claude Young-Clarke was first to voice his view on the subject.

'Doethn't theem to be too many here, Mr Wayer. Thtill, I might get the lotth I want a little cheaper.'

That, I thought, was a fair point. At this rate, there was every chance of him getting the whole sale fairly cheaply. Then, much to my relief, a few vehicles started to arrive down the farm track. The driver of the first got out and walked up to Mr Rayer. 'Who's the bloody Einstein who produced the directions to the sale on your leaflet?'

I watched, interested, for Mr Rayer's response. His bacon was saved by the presence of the driver of the second vehicle: 'Your bumph said to follow the "To the Sale" signs. What bloody "To the Sale" signs?'

This was deflected neatly in my direction. Mr Rayer showed true mental agility by turning to me and saying, 'Philip, I thought you'd put the signs up?'

I don't mind admitting I felt a little hurt by the flak landing in my lap and was about to put up a case for my defence when Mr Rayer went on, 'Philip, it's no use just propping the signs up in this weather, you've really got to drive them home.' And, having got the upper hand, that was what he did with his next comment: 'And, you know, you really must make sure you get your directions right before you send them out on a sales leaflet.'

The trouble was, there wasn't a hint of malice or nastiness so, no matter how wounded I felt, all I could do was mutter, 'Sorry, Mr Rayer.'

At least he had the charity to add, 'Don't worry, these things happen. It's best to learn from them.'

Aggrieved potential bidders duly placated, the sale was now due to start and, for once, Mr Rayer was ready to get going on time. A couple of locals had turned up but seemed to have no interest in any of the lots. However, one of them had a lot to say for himself and made sure he was overheard, in a very loud stage-whisper, 'Natural manures, he's certainly dropped us in natural bloody manures!'

There was now a small gathering round lot one. As with all farm sales, it was a quantity of scrap, in this case rusting corrugated-iron sheets. Mr Rayer started the bidding at five pounds and waited for someone else to bid. Nothing happened. He subsequently sold them to himself, as he did the next four lots, each for the same amount. As this sale was reasonably well organised and the lots followed one another in a straight line, we were making quite brisk progress – indeed, we were approaching the magical one hundred lots an hour that all auctioneers see as a minimum. Slowly but surely more people were arriving for the sale but few showed any interest in bidding, other than Mr Young-Clarke who was determined to buy anything that was half decent. Mr Rayer was getting stuck with all of the poorer lots that no one wanted. We appeared to have a sale with only two buyers. Everyone else simply stood in the background and muttered about how wrong it was for 'that bloody old thief' to be buying back most of the company's assets while he owed many of his neighbours huge sums of

money. The other predominant murmur confirmed, unsurprisingly, that the removal of the sale signs was part of a local conspiracy. There was no way the locals were going to bump up the proceeds by bidding on anything, and they had tried hard to ensure that those from out of the area had no idea where the sale was being held.

Eventually it came to a conclusion: Claude Young-Clarke had spent nearly eighty per cent of the sale proceeds.

'I thay, Mr Wayer, will a cheque thuffithe? I thpent wather more than I intended but it theemed quite a weathonable thale.'

Mr Rayer said that Mr Young-Clarke could pay by cheque but that he could not remove any of his purchases before his cheque had cleared. Until then he did not have title to the goods. I could see that Mr Rayer was pretty unhappy with the situation. I thought he was upset that, not for the first time, he had bought all the poorer lots that no one else wanted – he had spent about a hundred pounds on junk that at best would have graced a skip. But it transpired that that was not what had riled him.

'Philip, they just can't see it. The more the sale came to, the more they would have received as creditors. It was in their interests to bid on the lots – then old Claude wouldn't have got them and they would have got something back as a dividend in the company. As it is, he's bought most of the good lots and they're going to get less money.'

In the meantime Claude had made his way back to the main house and was now driving towards us. There are times in your life when you know that things might turn a little nasty. This was one of them. A group of farmers was accumulating round the shiny Mercedes. They were blocking its route and a lot of shouting was going on. I wasn't sure what to do or what would happen next. I turned to Mr Rayer, who was looking back up the farm track with a wry smile. There, coming towards us, was a tractor towing a muck-spreader. A very full muck-spreader. It was being driven by the farmer who had been so vociferous earlier. The others had gathered round Claude's car so that he had no idea of what was being driven towards him. Clearly this was a well-planned act of retribution. Mr Rayer, bless him, gave me a tap on the arm, pointed to the car and said, 'We'd better make sure this doesn't get out of hand, Philip – in a minute or two.' I'm sure there was a chuckle on his face. We both watched as the muck-spreader backed up to the shiny new car. Claude had no idea what was going on, such was the throng now around him. In a military-style manoeuvre the group of locals dispersed suddenly and the tractor-driver activated the muck-spreader. It went everywhere, plastering every gleaming square inch of Claude's car. Mr Rayer and I struggled not to laugh.

'Philip, I think we should put a stop to this.' Stable doors and horses bolting came to mind. As we walked up to the car, Claude was clambering out, absolutely cov-

ered with muck. It appeared he had had the car window down to remonstrate with the farmers and had taken pretty much the full brunt of the onslaught.

The driver of the tractor chortled and shouted, 'He wanted natural s**t. Well, now he's got some.' In any case, the locals had been justified in kicking up a bit of a stink . . .

Chapter Eighteen

Albert Accepts

It was a Friday night so Jim and I were enjoying a gentle pint in the Greyhound. Jim was overjoyed with his pipeline claim (here, an agent is employed by a farmer to assess the amount of compensation he should receive for a pipeline, normally a water authority's, that is installed across his land) and insisted on going into great detail over the minutiae of how the entitlement was worked out. Fascinating stuff, not dissimilar to watching paint dry. My day, on the other hand, had been interesting: I had been to a modern house in Malvern to offer an opinion on a few surplus items the owner was considering selling. I recounted the tale to Jim.

I had pulled up outside the house, which was modern, detached, on a small development of about six built in a style dating back to the eighteenth century. One of the real joys of this job is never knowing what, or indeed who, you're going to see next. I knocked at the front door, and a few moments later it was opened by a small

figure. I was somewhat taken aback: the young man was the same age as me and had a shock of shiny black spiky hair. He was wearing a pair of baggy black trousers – with no shirt. I stood on the doormat, which looked as though a shoe had never touched it, and waited to be asked in.

'You tek shoos and soks off!' my new client said. He was Chinese and looked like Cato from the *Pink Panther* films; he also had the advantage over me in that, not for the first or last time with a potential client, I had not the remotest idea what he was talking about.

'Prease, tek shoos and soks off!' he repeated, more animated. This had the potential to run on for some long time. Luckily I noticed that his baggy cotton trousers hung loosely over bare feet. Ah, well, when in Rome . . . I took off my shoes. I was a bit anxious about this: I knew I had clean feet but I was unsure of my socks. I should explain that I have always been an early riser but my brain doesn't always function too well early doors. I have been known to appear in the office in one black and one brown shoe, and an one notable occasion I arrived in a pair of brown corduroy trousers with a dinner jacket, which I'd thought, when I put it on, was a blazer. I took off my matching black shoes and was relieved to find a similarly matching pair of socks. I took them off, albeit feeling a little self-conscious in the middle of rural England. My host ushered me into his home. It was minimalist twenty-five years before its time and was

absolutely immaculate. It would have made a show-home look scruffy.

'You Mista Sellerr from orkshuneers?' I could see my name was a bit of a problem for him but his English was undoubtedly better than my Mandarin. I nodded. 'I wan' to sell few fings – have too much crutter in home.'

I looked round his immaculate, if Spartan, home and thought that if he sold too much there would be nothing left. The other problem looming up was that everything in his house was brand new – expensive but brand new. I couldn't see anything making much in the saleroom.

'Forrow me,' Cato said, and walked into the main reception room. 'How much you get for miller?' I was now panicking: Miller must be some modern artist about whom I knew nothing. Yet again I would be floundering. I looked around the room and couldn't see any paintings. 'Is good miller yes?' My client must have thought I was a complete idiot when he saw the vacant look on my face. 'There rook, gilt miller on war.'

Waves of relief washed over me as he pointed to a mirror. I wandered over to it. It was brand new and, while undoubtedly it had cost a fortune, had little value on the second-hand market.

'Wha' you think it make?'

I hate telling people that something they think is worth a lot of money will realise little in the saleroom. 'Well, the trouble is that while it's a really good mirror the second-hand market for things like this isn't that great.' That was

my standard opening gambit to pave the way for bad news.

'I know. I bought it. I know how much it cost. How much you think it make?' Cato could see through my flannel.

'Well, I don't think it'll make very much at all.'

I was about to carry on when Cato butted in: 'Mr Seller how much miller make?'

'About ten pounds.' Silence followed. And followed. I thought he would protest but he stared at the mirror, then turned his eyes to me. I wasn't sure if I should add anything as his piercing gaze continued but couldn't think of anything that would change the situation. After what seemed like eternity he spoke: 'I fink auction not best prace to sell miller. I also have some grass I wan' to sell. Wha' you know about grass?'

A feeling of *déjà vu* came over me as I stared round the room searching for something that might fit the description. Out of the window there was a small, perfectly coiffured lawn. While we had sold some wacky things I couldn't see him wanting me to sell his lawn. I glanced back at him and saw that his eyes were on a small, clear-glass vase on a low side table. It was the only ornament in the room. I wandered over to the table and picked it up.

'That velly expensive grass vase I bought from factree in Chinar.'

My response had a remarkably second-hand sound to it. 'Well, the trouble is that while it's a really good piece

of glass the second-hand market for things like this isn't that great.' I was going to have to polish up my delivery of bad news. I braced myself for the accusing silence, but Cato saved us both from further embarrassment.

'You fink that worth ten pound too?' I nodded. 'I fink auction not best prace to sell grass.' I was beginning to feel a little uncomfortable. Cato was so polite and charming and I was stumbling around like an idiot. 'Mr Seller, that is all crutter I have to sell – sorry if I wasted your time.'

He showed me politely to the front door and as he closed it behind me I was left to ponder, not for the first time, the vagaries of my new job. It had started to rain and I was standing barefoot outside a new house in the heart of rural England trying to put my shoes and socks back on.

Jim told me he reckoned pipelines were a safer bet. We had been in the Greyhound for about half an hour, each with an ever-emptying half, when the door opened. In walked Albert. 'I was on my way home and thought I recognised the two cars parked outside. Mind if I join you both for a drink?'

Jim and I nearly knocked each other over in our rush to offer her a seat and ask her what she wanted to drink. Our eagerness in the latter was tempered with the un-spoken knowledge that anything too extravagant would result in financial embarrassment for either of us. Jim

stepped in: 'You get the first, Phil, and I'll do the next.' I wasn't quite sure of his motive but felt there was a certain amount of bridge-building to be done on my part between Albert and me, so I allowed him to get away with letting me buy her the first drink.

'An orange juice will be fine, thanks.' God bless Albert. We sat down and told her about our pipelines and Chinese clients. I have to say that she seemed far more interested in what I had to say than Jim but, then, I didn't know many girls who would be riveted when Jim got into his stride about pipeline compensation claims. His other big interest was farming tenants' manurial rights but, thankfully, he didn't go there. Instead he decided a call of nature was necessary. While he was away I thought it an appropriate moment to apologise for the catalogue of disasters that had befallen Albert and me to date. Before I could say anything, though, she said, 'I haven't seen you for some time. I wanted to apologise for everything that seems to have gone wrong. I felt so awful about your car on the evening of the cricket club do that I didn't know what to say.'

I didn't know what to say now. I'd been about to start grovelling and explaining and here was this lovely girl apologising for the grief to which I had subjected her. 'Look, there's no need to say you're sorry – I feel pretty awful about it all myself. I thought I'd be the last person you wanted to see and decided to keep my head down.' Then I decided to take the bull by the horns: 'I don't

suppose you'd risk another date? Perhaps you'd come for a drink and some grub one night next week?'

'I'd love to.'

At that point Jim returned and offered to go the bar for more drinks.

'Not for me,' said Albert. 'I must get home. My parents are having some friends round for dinner.'

I was so bowled over by her acceptance that I didn't even notice Jim hadn't bought her a drink. I was miles away, watching her walk elegantly through the doorway, when Jim interrupted me: 'You've got a bloody stupid smile on your face. What's she said?'

Chapter Nineteen

A Fight with a Filing Cabinet

I had that stupid smile on my face all weekend and pitched up at work on Monday morning feeling, yet again, that the world was a good place to be in. I even took to making regular trips out of the office, ensuring that I had to pass Lloyd and Gold's offices where, each time, I got a beaming smile and a wave from Albert. There was one slightly embarrassing moment when Jim was in the office behind her and I saw him playing an imaginary violin and blowing kisses at me.

Work for the week was fairly standard and I could see no problems looming to scupper my Friday-night date. There was an auction at the saleroom on Thursday but it was relatively small with nothing, I thought, of spectacular merit, and it had already been lotted. But if I spent most of my week at the saleroom I wouldn't be under Mr Rayer's nose, reminding him of his constant quest for new experiences in the world of auctioneering and valuing to bestow on me.

So, on Wednesday I was safely ensconced in the sale-room. There was no formal viewing on Wednesdays but members of the trade would pop in to see what was coming up for sale the following day. One of those who called in was a local dealer who ran a very successful business. I guessed she was about my age and was a second-generation dealer – I had been at school with her younger brother. She wandered round the saleroom and eventually came into the office. 'Philip, there's a lovely Georgian mahogany three-tier dumb waiter out there towards the end of the sale. What's it going to make?'

The piece in question was like a circular table with two similarly circular pieces of timber, about eighteen inches apart, arranged on top of the lower piece. A column separated the three graduated tiers and each piece could be revolved around it. The lower section was also raised on a column, which terminated in a tripod base. It dated, I would guess, to about 1790. It was used by diners to help themselves to additional plates, cutlery or food.

This dealer bought excellent pieces and presented them beautifully with informative labels in her shop by the cathedral in Worcester. She always had real gems for the earnest collector. There is an expression in the antiques business: 'If the only thing you have to apologise for is the price then it's worth looking at.' The items in her shop were fairly priced but not cheap, which reflected the quality that was on offer and what she had had to pay in the first place. Her interest in the dumb waiter proved

instantly to me that it was a good piece and she would bid a fair price for it. She had inherited her father's astute business acumen and was a canny buyer: if she wanted a lot she was rarely outbid. I told her I thought it might make about three hundred pounds.

'I'd like to bid on it but I don't want anyone else to know I'm interested. Any suggestions?'

I came up with a cunning plan: with the heaters turned off it was bitterly cold in the saleroom and she was wearing a scarf. I suggested that if she wore her scarf when the lot was being sold I would bid on her behalf. If she took the scarf off I would stop bidding. It was a simple plan, I thought, but it had the hallmarks of genius.

'Well, if you're sure that's OK with you, Philip, but I don't want to cause any problems.'

I didn't see how anything could go wrong and told her I was happy with my little scheme.

A few other dealers popped in during the afternoon and the dumb waiter was the centre of their attention.

'Much interest in the dumb waiter?' was an often-asked question. At times like this an auctioneer should keep his own council and not divulge any information he has concerning the interest of other dealers. Put simply, if an auctioneer tells anyone else what interest or commission bids he has it's counter-productive. Eventually all of the trade will find out and not leave any bids. My reply was a fairly standard 'No more than you'd expect for a decent lot.'

That evening I called at the Greyhound and met up with Jim. He came out with all sorts of quips and remarks about my forthcoming date with Albert. His line of questioning centred pretty much on what I was going to do this time to put the mockers on things. I must admit it did bother me but I hadn't planned any of the other catastrophes that had occurred with Albert – they'd just happened. Jim had even offered me some of the expensive aftershave he'd been given for Christmas. 'Can't have you smelling of cats' widdle again,' was a conclusion I couldn't argue with. I told him I was going to take Albert for a drink and some good simple English fayre so there would be no danger of the repeating faggots. 'Well, you just want to make sure Ten o'Clock doesn't get you on some other bloody trip again to Outer Mongolia to value some native sheep,' Jim observed sarcastically. This did worry me a little: I could plan everything but Mr Rayer was a law unto himself.

Thursday morning came and I made my way to the saleroom. The sale duly began and all was progressing pretty much as expected. The lady dealer appeared in the saleroom when we had got to about lot 250. She was always impeccably dressed and her scarf was neatly in place round her neck. For some unknown reason Mr Rayer had decided to switch on the heating. This was a rare occurrence, almost unknown during my time with him – he had the constitution of an ox and normally only resorted to turning it on when polar bears had been

sighted in Malvern. The weather had also taken a bit of a turn and the temperature had risen; it was quite warm. We were getting closer to the dumb waiter and the lady dealer took off her scarf. I don't know why but I suddenly developed a mental block: was it scarf on or scarf off when she was bidding? Everyone else in the room might have been quite warm in there but I was getting the dreaded auctioneer's cold shivers. No, it was definitely scarf off and she was bidding – wasn't it? Mr Rayer was selling at his usual slow, steady pace and I changed my mind so many times on when I was supposed to bid that when we arrived at the lot in question I was punch-drunk.

The bidding started at two hundred pounds and the lady dealer had her scarf on. I had remembered, definitely, that this meant I was not to bid so I did just that: nothing. Then she started to bid herself: I was right, she was a canny one. I had worked out her plan: she had a reputation for being a strong buyer so when everyone else saw her stop bidding they would think it was enough money. She would then take off her scarf and I would bid for her and no one else in the room would know that she was, in fact, still bidding. Simple, but an inspired bit of kidology. At £560 she stopped bidding and took off her scarf. This was my cue and I started bidding for her until the hammer came down at £640. I was delighted that we had pulled off such a cunning plan. There were only fifteen lots left in the sale and at its conclusion I walked

up to her and was about to congratulate her on her success when she said, 'Who bought the dumb waiter, Philip?'

The cold shivers struck again, and I mumbled, 'You did.'

She explained gently to me what we had originally agreed. What an idiot I had been. She was gun-barrel straight in business so there was no question of her trying to pull a fast one. I felt such a fool.

I sought out Mr Rayer and told him what had happened. He knew the lady in question and had sold a number of things to her and her father over the years so he was quite satisfied with her integrity. The question was, would he be so happy with the stupidity of his trainee?

'Well, Philip, you seem to have made a hash of things here. Leave it to me and I'll try to sort it out for you.' I could have hugged him.

Mr Rayer went to the under-bidder, who was a collector and really wanted the piece; seemingly he regretted not raising his hand to top the final bid. He generously agreed to stand by his last bid at which price Mr Rayer agreed to sell it to him. 'We'll make up the balance so the vendor doesn't lose out. Best not to make a simple thing too complicated in future, Philip.' The man was a diamond.

The next day I went into the Worcester office with mixed emotions. I was looking forward to my night out

with Albert and didn't want anything to get in its way. However, I knew that whatever Mr Rayer wanted me to do that day I couldn't refuse as I was, yet again, in his debt. Literally.

'Philip,' Mr Rayer hailed me cheerfully, 'we'll have a day in the office. I want you to help with some plans this morning and then I want to bring that filing cabinet down from upstairs and we'll rearrange some of the files in my office.'

That sounded fine; valuing Mongolian sheep was not on the agenda. I had half expected a trip somewhere or other and had come to work in my one and only suit as there was a distinct possibility that I would be picking up Albert having had no time to change. Much more cheerfully now, I asked Mr Rayer what he wanted me to do with the plans.

'Well, Philip, a lot of the old estate plans that we keep for clients are mounted on large pieces of old card and I want you to trim them down with the guillotine so they're more manageable.'

That sounded quite simple. I gathered up the plans and took them into the room where the guillotine was kept. It was an instrument from the torture chamber, comprising of a huge blade about three feet six long, which was mounted on a strong spring, and on a flat board about four feet square. The spring was so strong that it cut through normal paper like butter; the downside was that it was a Herculean task to force the blade down, and

having got the thing in a downward motion it was impossible to stop. This meant that the paper for cutting had to be placed in precisely the right position as there was no second chance. It had certainly been constructed in the nineteenth century but, as Mr Rayer always said about such things, 'It does the job, Philip. No need to replace it with some new-fangled machine that does half the job.'

Everything went well with the first plans and I was pleased with the results. The last, however, was determined to put up a fight. I slammed the blade down and it barely bent the card the plan was mounted on. I tried several times with the same ineffectual result. I decided the only way to do it would be to hold down the plan with my knees. I put one arm close to where the blade came down so that I could hold it firmly in place and ensure a clean cut. With the other I would lift the blade to its highest point and slam it down with all the strength I could muster. This was a resounding success: it sliced through the plan as though it didn't exist. Regrettably it also had the same effect on the cuff of my suit jacket, slicing off a triangular patch of material. I was absolutely mortified. It was my only suit and it certainly wouldn't impress Albert now. I felt a complete ass, and such was my embarrassment that I even tried to reaffix the material with a stapler. Invisible mending it was not.

Lunchtime arrived without further excitement, and in the afternoon I had the dubious pleasure of moving a

filing cabinet down some stairs with the one-legged man.

'Philip, we'll tie some webbing round the cabinet and lower it down the stairwell.'

The stairs comprised several flights of ten or twelve steps. Each flight ended in a half-landing with the next set leading off at ninety degrees. This meant there was a well in the middle of the stairs that went from the bottom to the top of the building. The filing cabinet was to be moved from the third floor to the second. We lashed webbing round it and balanced it on the banister.

'Philip, you go down the stairs, I'll take the weight and lower it down to you.'

I didn't like the sound of this but bowed to Mr Rayer's superior military logistical skill. I positioned myself on the second-floor landing and shouted to Mr Rayer that I was ready. As I looked up the metal filing cabinet began its descent slowly towards me. So far everything seemed to be running smoothly.

'Steady as she goes, Philip,' he called. Absolutely, I couldn't agree more, not that there was anything I could have done about how steady she went. Suddenly, however, the cabinet was gathering speed and I saw to my horror that the webbing Mr Rayer was supposed to be holding was flapping around in its wake. There are times in life when you know you should move, fast, but for some unknown reason you can't. You remain rooted to the spot staring at the impending doom. It didn't really hurt as it hit my head, then the arm, and rebounded on to

my leg. The cabinet came to a halt on the landing and I looked at the floor, expecting to see blood, as Mr Rayer shouted, 'Look out, Philip!' Perhaps the blood would come later. All there was on the floor was a bent cabinet and a cloth. *Cloth?* The damn cabinet had taken a six-inch strip out of the suit sleeve that the guillotine had spared and a similar length had gone from my trouser leg.

By now Mr Rayer was standing beside me. 'You're going to have a right shiner there, Philip. Still, never mind, we can get those clothes invisibly mended.'

By whom? I wondered. A magician?

So, I wasn't going to be late for my date with Albert. I was just going to look as if I'd been involved in the mother and father of all fights. Perfect.

Chapter Twenty

～

The Start of Something? . . .

The big night had finally arrived. Not only did I manage to get home on time but I washed and spruced up the Mini as well as myself. The only minor blemish was my right eye. After its close encounter with the filing cabinet I looked as if I'd done fifteen rounds with Muhammad Ali; there was a cut and a bump the size of a goose egg. I could do nothing to disguise it and at least I had a good excuse for its presence, so I set off in a high good humour – until it started to rain. Ooby instantly started to show off her sieve function and my trousers were slowly but surely soaked. Ah, well, after all that had gone before on my dates with Albert I suppose my eye and trousers were fairly trivial nuisances.

I pulled into the drive and 'Mrs Albert' answered the door. 'I'll just let Rosemary know you're here. Goodness, what on earth have you done to your eye? You haven't been in a fight, have you?'

Great. Albert's mother now thought I was some sort of

street brawler. But before I could refute it, she went on, 'And, look, your trousers are all wet!' Not just a hooligan, an incontinent hooligan. 'Do come and sit with my husband while I call Rosemary.'

The thought of having to spend more time trying to make conversation with 'Mr Albert' was more than a little daunting, but there was no point in protesting. At least if he was buried in his newspaper he wouldn't notice the state of me. I walked into the room and my heart sank: the newspaper had gone and was replaced by a stern face that just stared at me. I sat down and attempted to chat politely but all my remarks were met with monosyllables. After what seemed a lifetime Albert appeared, looking fabulous. We said our goodbyes and made our way hastily out of the door to Ooby.

'Look, Albert,' I said, then realised I'd called her by her secret nickname. 'Oh, my God, I'm sorry – I mean Rosemary – look, I really am sorry.'

She started to laugh. 'Don't worry. Jim doesn't know it but I'm fully aware of that nickname – and have been from day one.'

I laughed too, somewhat relieved. 'Your father didn't look very pleased to see me,' I said, then regretted it: it was hardly politic to suggest that her father was anything but a charming fellow who had just welcomed me into his home.

'He's always like that. You look like you've been in the wars. What happened?'

I explained, and she kindly reassured me: 'I know we'll have a lovely evening.' Fingers crossed. That was what I'd intended on all the other occasions we had met.

We went to the pub, and I made sure that she was served decent home-cooked food. As we ate, we seemed to get on really well. I thought it was time to offer some sort of apology and explanation for our previous disastrous meetings – and, more to the point, why I had spent so much time avoiding her. I confessed that I had been embarrassed.

Albert burst out laughing. Then she took me by surprise: 'I thought you were avoiding me because I'd embarrassed you, not the other way round!' Bloody hell, that was a revelation. She went on: 'I really wanted to see you again but I thought you didn't want anything to do with me.' Perhaps all was well with the world after all.

We had a thoroughly enjoyable evening but, all too soon, the time came for me to drive her home. By then it was raining quite heavily but I hardly noticed the constant drip on my trouser leg. Foolishly, as it later turned out, I decided to take the lanes rather than the main roads. There was no dodgy ulterior motive on my part – it had been such a good night that I simply didn't want it to end. We were about two miles from her house when Ooby did an extraordinarily accurate Windy Williams impression: coughed, popped and came to a grinding halt. I looked at the petrol gauge. Empty. Here we go again, I thought. 'You're not going to believe this but I'm

afraid we'll have to walk, I really am so sorry.' I got out of the car and went round to her side of the car to open the door.

As Albert climbed out there was a clap of thunder and the rain turned into a deluge of biblical proportions. As we trudged off, abandoning Ooby in the dark lane, I looked at Albert and she looked at me – and we laughed. Perhaps this was the start of something? . . .

Acknowledgements

B and C.S.; J, M and W.R.; E.B.; R.T.; R.L., K.H. and H.W.